IMAGES
of America

MOORPARK

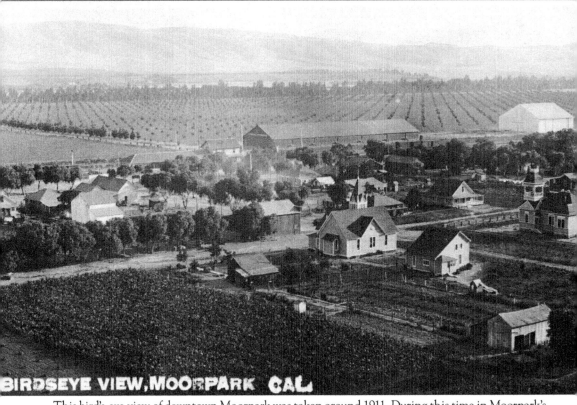

BIRDSEYE VIEW, MOORPARK CAL.

This bird's-eye view of downtown Moorpark was taken around 1911. During this time in Moorpark's history, housing was concentrated in the downtown area and, except for the outlying ranches, had not yet moved south of the railroad tracks. The land beyond the Southern Pacific Milling Company warehouse, which would be Poindexter Avenue today, is planted with young walnut trees. (Courtesy Moorpark Historical Society.)

ON THE COVER: Completed in 1896, the majestic Fremontville schoolhouse was originally built on two acres of land donated by the Agoure family near the intersection of Spring and Peach Hill Roads. The school needed to maintain eight students to ensure funding for a public school teacher so enrollment was open to children from surrounding communities. This c. 1904 photograph shows the teacher, Etta Ayers, with the student body. (Courtesy Moorpark Historical Society.)

IMAGES
of America
MOORPARK

Michael Winters

TO MARY —
THANK YOU for ALL THAT YOU HAVE
DONE TO SUPPORT THE STUDENTS of
MOORPARK !

ARCADIA
PUBLISHING

Published by Arcadia Publishing
Charleston, South Carolina

Library of Congress Control Number: 2016938023

For all general information, please contact Arcadia Publishing:
Telephone 843-853-2070
Fax 843-853-0044
E-mail sales@arcadiapublishing.com
For customer service and orders:
Toll-Free 1-888-313-2665

Visit us on the Internet at www.arcadiapublishing.com

*To my family, Erin, Emma, and Lily, and to all of the
residents of Moorpark—past, present, and future*

CONTENTS

ACKNOWLEDGMENTS

This book would not have been possible without the support of the Moorpark Historical Society and its board of directors—David Schwabauer, Linda Plaks, Patti Reuter, Diana Gould, Chris Childers, Gwyn Goodman, and Bill McMahon. Thank you, to these individuals and also to former board members Charles and Mary Schwabauer, who have worked tirelessly over the past many years to preserve Moorpark's history.

A great source of inspiration for this work has been *The Moorpark Story* and *A Diamond for Moorpark* by Norma Gunter and *Moorpark: Star of the Valley* by Janet Scott Cameron. Thank you, to these two authors for their contributions to our city.

Thank you, to Jim and J.J. Birkenshaw, Rick and Linnea Brecunier, Joy and Curran Cummings, and Gwyn Goodman for their generous contributions of images.

Thanks also go to Simi Valley historian Bill Appleton and to Carolyn Phillips, Patricia Havens, and the board of directors of the Simi Valley Historical Society for their generosity in contributing images.

Thank you, to my siblings, Paty, Danny, and Matt, for their lifelong support, and to my parents, Larry and Nancy Winters. I am so glad you stumbled upon that little farmhouse in Home Acres in 1961 that would provide me with so many great memories while growing up.

Lastly, I would like to thank my daughters, Emma and Lily, and my wonderful wife, Erin, who has been a constant source of strength and reason throughout this process. Without her support and understanding, this book would have not been a reality.

The majority of the images used in this work are from the collection of the Moorpark Historical Society. These images have been collected by the society or have been donated from the town's founding families over the past 50 years. Without these images, I would not have been able to complete this project. Thank you, to all of the families who have made it a priority over the years to preserve Moorpark's history through their generous donations of photographs and ephemera. Unless otherwise noted, all images appear courtesy of the Moorpark Historical Society archive.

INTRODUCTION

As a teenager growing up in Moorpark, I was bitten with the model railroading bug when I joined the Home Acres 4-H Club's model railroading project. I soon began brainstorming ideas for a train layout and, since I was interested in history, the project leader suggested I create a layout of old-town Moorpark. Because I was no expert on Moorpark's past, I began brushing up on local history by reading my parents' copies of Norma Gunter's *The Moorpark Story* (1969) and *A Diamond for Moorpark* (1975.) Since my mom knew Norma Gunter from working at the bank, she arranged a driving tour with her so I could gain some insight as to what the town looked like in the early years. This trip through downtown Moorpark took no longer than 30 minutes but sparked in me a lifelong love of our city and its rich history.

This work serves to build on the foundations laid by Gunter's aforementioned works, as well as on Janet Scott Cameron's *Moorpark: Star of the Valley* (1967.) As these previous works presented readers with a dialogue-rich historical narrative, the purpose of this work is to provide the reader with a more visual representation of Moorpark's past through the use of historical photographs and ephemera.

This book contains a mixture of published and never-before-seen pictures of Moorpark and the surrounding areas. They represent the history of Moorpark from the town's humble beginnings through the 1930s. Each of the photographs has been scanned at a high resolution and, even if previously published, will provide the reader with a higher-quality and more appealing historical representation of the town.

As Moorpark was founded 115 years ago, it was very difficult to locate images of the town's founding families. This was especially true in trying to locate images of those Mexican American families who contributed so much to the town's early years. The absence of photographs of this important group of individuals, or of any individuals that played a historically significant role in the town's history, should in no way take away from the many contributions they made to the development of Moorpark.

Moorpark's past can be traced back much further than most residents can imagine. Long before the rolling hills surrounding Moorpark had been developed and even before they were being farmed, this area was home to some incredible creatures. In 2005, one of the world's most complete southern mammoth (*Mammuthus meridionalis*) fossils was uncovered during excavations in the Meridian Hills housing development just north of downtown Moorpark. This fossilized mammoth skeleton, affectionately referred to as "Big M," is now being painstakingly restored at the Santa Barbara Museum of Natural History. This find, however, was not the first mammoth to be discovered in this area. Newspaper accounts from 1928 report that the fossilized remains of another mammoth were excavated that year in the hills surrounding Moorpark.

Many years after the mammoths became extinct, the Chumash lived and traded in the area we now call Moorpark. The Chumash village of Quimisac was located in the Happy Camp region northeast of town while the nearby villages of Shimiji and Ta'apu (Simi and Tapo) were located

in present-day Simi Valley. The Chumash were hunters and gatherers and traveled between villages to trade. According to historians, Quimisac controlled the local trade of fused shale in this region, which was used for tools and projectile points. The largest deposit of fused shale in California is located in Grimes Canyon.

The Chumash lived in familial groups in villages and would make trips to gather seeds, sage, acorns, and other dietary staples. Food was stored in coiled baskets and kept inside dome-shaped thatched dwellings. The Chumash would also embark on hunting trips and used bows and arrows and throwing sticks to take down their prey.

Once the Spanish arrived in California, the Chumash and Spanish began to interact and trade. Spanish missionaries also worked to convert the Chumash to Christianity. The records of the San Buenaventura Mission contain references to baptisms of Chumash residents of Quimisac. After 1803, reference to this place name disappeared from the mission records.

In 1795, the Rancho San José de Nuestra Senora de Altagarcia y Simi (Rancho Simi) land grant was given to Francisco Javier Pico and his brothers by Gov. Diego de Borica. The word *Simi* is derived from the name of the Chumash village of Shimiji. This 113,009-acre land grant was made up of what is today Simi Valley and Moorpark. The Pico brothers built a large adobe in the early 19th century and resided in that location until they sold the property in 1842. The Simi Adobe at Strathearn Historical Park and Museum has been designated a California Historical Landmark.

The land grant changed hands periodically over the years before it was finally purchased by the Philadelphia and California Petroleum Company. When oil was not discovered in great quantities, the land was sold off and a portion of it was eventually purchased in 1887 by a land development group called the Simi Land and Water Company. Robert W. Poindexter, the secretary of the organization, would eventually end up with the plot of land that became Moorpark.

Poindexter and his wife, Madeline, first developed a small farming community west of present-day Moorpark called Fremontville. A group of retired Methodist ministers had already set up another farming community northwest of town called Epworth. When Poindexter learned that the Southern Pacific Railroad would be rerouting its coast line through Ventura County, he established the townsite of Moorpark in 1900, and the railroad ran directly through the town. By March of that year, a depot had been constructed and a store, hotel, and other buildings were moved from Fremontville to High Street. Moorpark was now on the map.

Growth in Moorpark really began to flourish after 1904 when the tunnels in the Santa Susana Mountains on the east end of Simi Valley were completed. These tunnels now allowed trains to travel to Moorpark from both the east and west. The railroad was the lifeblood of the town and not only brought townspeople commerce and information, but also helped the town to export its greatest commodity—its produce.

For most of its existence, Moorpark's economy was based on agriculture. In the early years, dryland farming of crops like beans, hay, and apricots was preferred, as they required little irrigation. As additional wells were drilled and irrigation systems improved, walnuts and citrus became some of the desired crops due to the higher premiums they brought. Moorpark produced so many apricots that it was referred to as the "Apricot Capital of the World" and by the late 1920s was hosting a yearly apricot festival. After World War II, agriculture continued to play a large role in the economy but the poultry industry also became big business in Moorpark with turkey, chicken, and egg ranches dotting the landscape.

One

EPWORTH
AND FREMONTVILLE

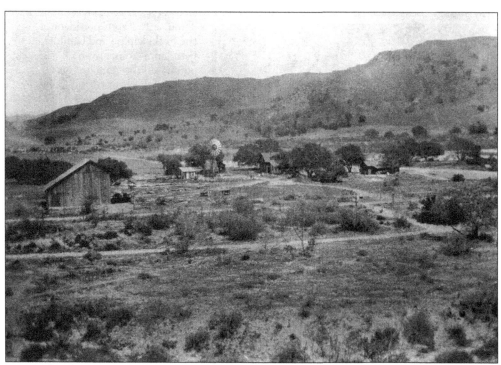

W.T. Richardson was an early settler in the Little Simi Valley. His ranch, Echo Point, was located east of town and just south of what is now the Collins Road exit from the 118 Freeway. Richardson raised bees and fruit and was an early postmaster. In 1903, Richardson sold his ranch to Spencer R. Thorpe and his apiary to F.E. Bagnall and J.S. Appleton of Simi. (Courtesy Bill Appleton.)

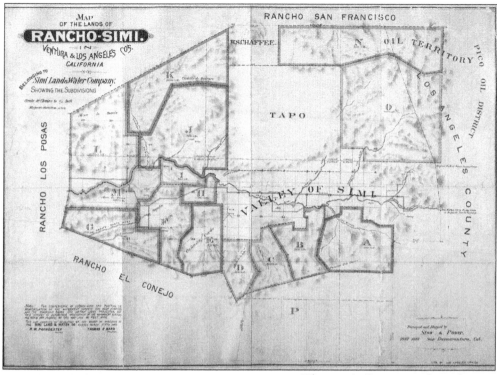

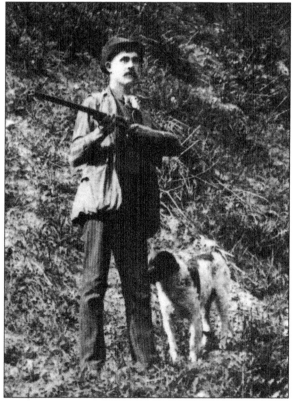

Thomas A. Scott, president of the Philadelphia and California Petroleum Company, had purchased the Rancho Simi in hopes of discovering oil. Upon Scott's death, Thomas R. Bard was tasked with disposing of his holdings, and the Simi Land and Water Company was formed. This map, dated 1888, shows the many subdivisions that were created. Moorpark was later developed in Tract L. (Courtesy Huntington Library, San Marino, California.)

Robert W. Poindexter, secretary of the Simi Land and Water Company, acquired the land where Moorpark is located today. He developed the town in 1900 and, although not a permanent resident, maintained a ranch near what is now known as Poindexter Avenue, until he sold off his landholdings. Here, he is seen hunting quail in the Santa Susana hills. (Courtesy Ventura County Museum of History and Art.)

Oscar J. McFadden was one of the earliest settlers in Epworth. He was a retired Methodist minister who came to try his hand at farming. McFadden acquired many plots of land, including 25 acres from Dr. George F. Bovard, who was the first president of the University of California. The McFadden family kept the 425-acre ranch until 1942, when they sold it to the Herrington family. Inside this document, McFadden lists the plethora of different trees that he planted: French prunes, royal apricots, white smyrna figs, English walnuts, paper shell almonds, and both mission and Rubra olives. The October 19, 1901, edition of the *Oxnard Courier* reports that Southern California had a bumper olive crop and they were preparing to pack 6,000 barrels of olives, which was more than double the average crop during the previous years.

O. J. McFadden

TO

C. W. Hilton & Sons

LEASE

Dated _Nov. 1st_ 1893

Expires _Nov 1st_ 1896

Recorded at the Request of

_____ 188__

at _____ minutes past _____

__M., in _____ of Leases __,

page _____ _____ Records of

the _____ _____ County of

_____ County Recorder.

By _____

Deputy Recorder.

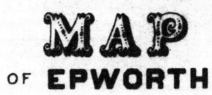

MAP
OF EPWORTH
A SUBDIVISION OF THE EAST END OF MESA DE SOMIS.

A PART OF

LOT 'L' OF THE RANCHO SIMI
VENTURA CO. CAL.

Surveyed May. 1893.

by C.A.Bradley

There are two historical documents that help pinpoint the formation of Epworth. The first is a map recorded with the county on June 9, 1893. The second is a post office application dated October 10, 1892. The application does not specify Epworth but requests that the post office be situated in the Fairview School District. The post office was named Penrose. (Courtesy Ventura County Museum of History and Art.)

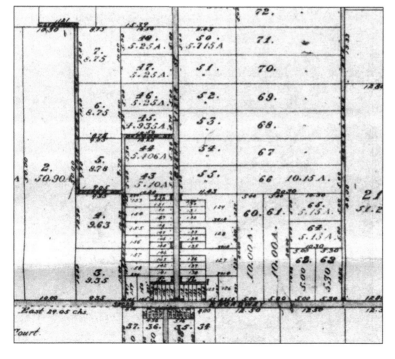

Although the 1892 post office application states there is "no village" in the proposed location, this map detail from 1893 lays out a townsite and a number of streets. Broadway, Fruitvale, Fair Oaks, Oxford, and Tucker are all streets that still exist in this location. The application also states that 110 people would eventually live in this area. (Courtesy Ventura County Museum of History and Art.)

John Wesley helped to found the Methodist movement in England during the 18th century. The retired Methodist ministers who founded this new colony named it Epworth as a nod to Wesley's birthplace. The chapel they built in 1894 was also named the Wesley Chapel in his honor. The church was built just north of Broadway Road on what is now the Leavens Fairview Ranch and was moved to Moorpark in late 1906. (Courtesy Bill Appleton.)

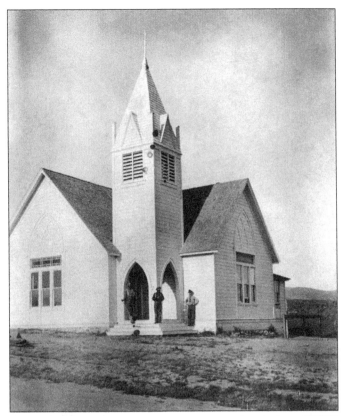

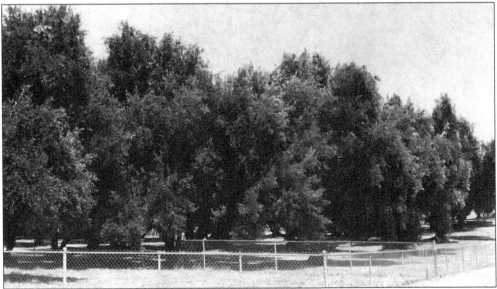

In a souvenir agricultural edition of the *Moorpark Enterprise* newspaper, Oscar McFadden writes, "Just as the orange, lemon, apricot, walnut and other industries came back to a sound and profitable basis, so will the olive, and as the orange is king, so the olive will be the queen of California's unique products." The olive trees pictured planted by McFadden over 100 years ago are still alive and producing today.

This house located on Fruitvale Avenue in Epworth was home to W.K. Fish and the Woodside family. The July 11, 1903, issue of the *Oxnard Courier* states that, "W.K. Fish and Son in Epworth have the largest number of pitters and drying force on Land, more than sixty five hands being employed." It also states that other apricot growers in the area were gearing up for an abundant harvest.

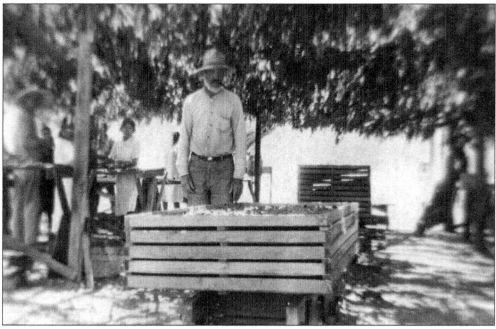

This early photograph of John Delaway shows him on the Freeman Ranch in Epworth during the apricot harvest. In 1909, Delaway's wife, Mary Reese, passed away and left him to care for his three young children. The 750-acre ranch was acquired by the Leavens family in 1943, and the Leavens Fairview Ranch is still in operation today.

John Delaway's home dates from the turn of the 20th century and was built by Oscar Freeman, an early settler in Epworth. The home is located on the south side of Broadway Road. The upper story started out as a hayloft, while the ground floor served as a livery stable. Delaway converted it to a comfortable living space, and it is still in use as a home on the Leavens Fairview Ranch.

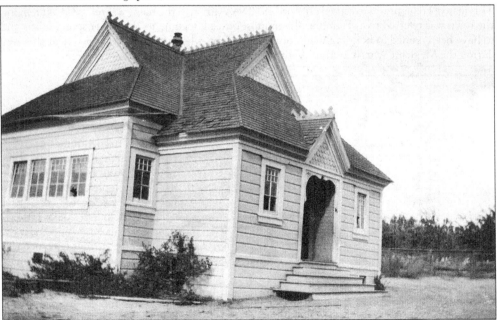

Completed in 1891, the Fairview schoolhouse was quite a luxury for the families that lived and farmed in the Epworth area. As Moorpark grew and the population of the Fairview area diminished, there was no longer a need for the old schoolhouse and the Fairview School District eventually combined with Moorpark to form the Moorpark Union Elementary School District.

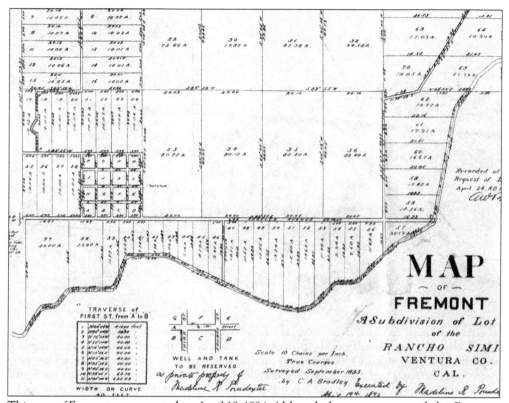

This map of Fremont was executed on April 19, 1894. Although the name was recorded as Fremont, the town was referred to as Fremontville in most official documents and other sources. It is said to have been named in honor of Gen. John C. Frémont, who purportedly stopped near this area during the Mexican War. (Courtesy Ventura County Museum of History and Art.)

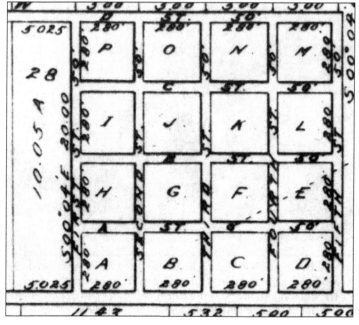

This detail map of Fremontville shows the layout of the townsite, complete with a well. It was located on the north side of Los Angeles Avenue near the current entrance to Moorpark Estates. Since the townsite was not active, the county board of supervisors moved to abandon the streets in the town on June 15, 1900. (Courtesy Ventura County Museum of History and Art.)

This image of Mary Willard, who later married Frank Cornett, is one of the only verified images of the Fremontville schoolhouse in its original location on the Agoure Ranch in Peach Hill. Willard only taught at the school for one year before moving on to other endeavors. In later years, however, after the schoolhouse was moved to Moorpark, she became principal.

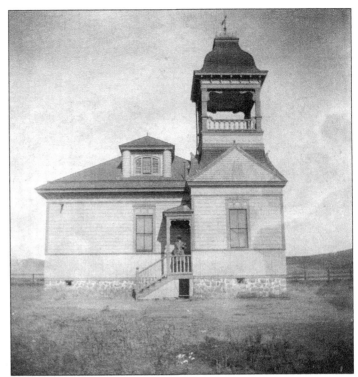

In 1903, when Mary Willard was a first-year teacher in Fremontville, she relied on her brother Warren to take her to and from school each day. Because roads could be treacherous, students traveling to school from the north had to cross the Arroyo Simi to get to the schoolhouse.

These two images were taken from a large panoramic view of the Aratus Everett Ranch that was taken around 1905. Everett was an early pioneer in apricots in the area and purchased his ranch, the Mountain View Orchard Ranch, around the turn of the 20th century from James Evans. To increase sustainability, Everett built an apricot nursery on his property and had 219 acres of apricots that were in a high state of cultivation. Apart from apricots, he also laid out 158 acres in beans and hay and 252 acres of his 1,580-acre tract were irrigated. Everett's ranch contained seven wells for soft water and three that were used solely for irrigation. (Both, courtesy Rick and Linnea Brecunier.)

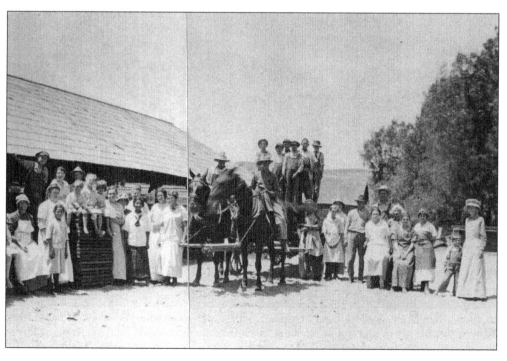

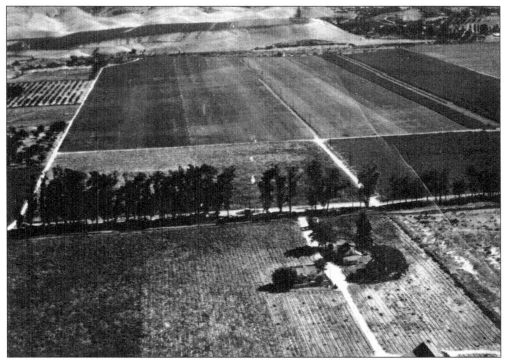

Henry Columbus Estes left his home in North Carolina at the age of 12 and hitchhiked across the United States. He eventually came to Moorpark and purchased a ranch on the north side of Los Angeles Avenue, which is pictured in this aerial view looking south. The Estes house was located just west of the Southern California Edison Substation. The ranch eventually went into disrepair and was demolished.

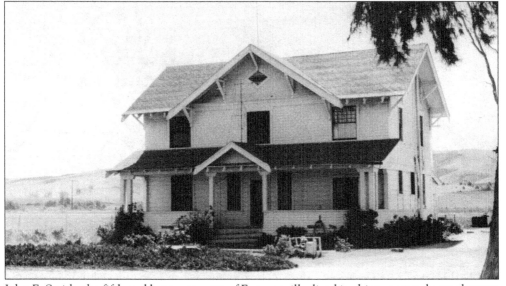

John E. Smith, the fifth and last postmaster of Fremontville, lived in this two-story home that was located where Muranaka Farms is today on the south side of Los Angeles Avenue. This house served not only as the family residence, but also as the Fremontville Post Office. The house was at one time also owned by Clarence Everett and, in later years, became the home of the Hitch family.

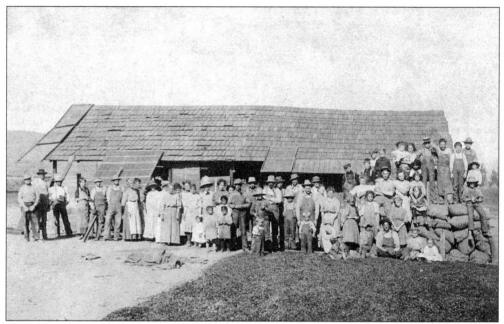

John and Ellen Davis purchased a ranch in the hills north of Los Angeles Avenue, located behind the Estes Ranch. Like many early farmers in Fremontville, John successfully raised black-eyed beans before moving into walnuts and apricots. This photograph illustrates the large labor force that was needed during bean harvesting.

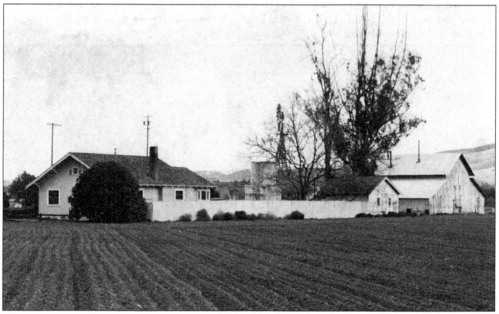

The birthplace of Monroe Everett, this single-story ranch house was typical of homes in the Fremontville and Moorpark areas. Large barns were necessary to store equipment and supplies used to carry out the many functions of ranching. Drinking and irrigation water was also a necessity. Windmills, and later gas and electric pumps, would take the water from wells and deposit it in storage tanks. (Courtesy Rick and Linnea Brecunier.)

Two

THE RAILROAD

Ruby Williams came to Simi around 1922 and later worked in Moorpark as a telegrapher for the Southern Pacific Railroad until her death in 1958. Here, she can be seen in 1953 preparing a train order. Orders were fastened to a string connected to a wooden fork. As the train passed, engineers would put their arm through the loop and catch the fork. (Courtesy Simi Valley Historical Society and Museum.)

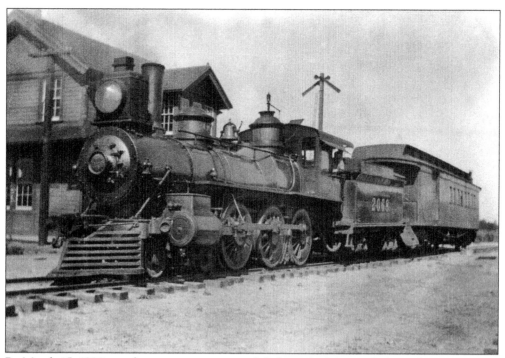

By March 15, 1900, regular train service arrived daily to the Moorpark depot from Montalvo. The *Ventura Free Press* reported, "The new station looks businesslike. A fine depot—somewhat larger than at Ventura—a section house all completed: corral and shutes for cattle . . . The site is a beautiful one nestling close to the hills." This c. 1906 photograph is the only documented image of Moorpark's first depot. (Courtesy Bill Appleton.)

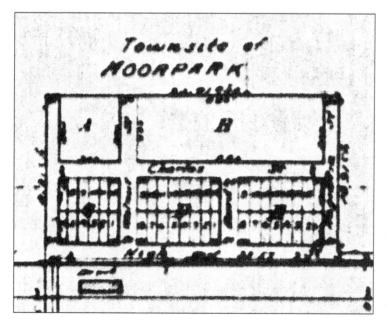

This detail from a November 1900 map of Moorpark shows the importance that the railroad played in the design of the town. The tracks lay just south of the town's main street, High Street, and the rectangle at the bottom left of the image shows the location of the depot. The depot was also the home of Moorpark's first post office. (Courtesy Ventura County Museum of History and Art.)

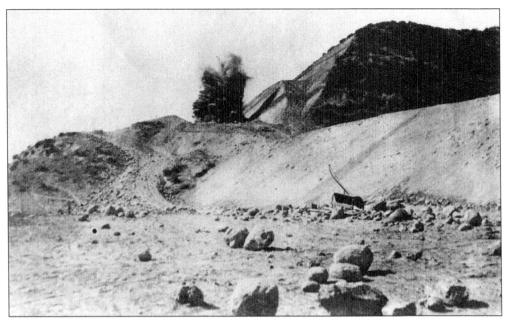

Work on the seven-mile stretch from Somis to Moorpark was completed by February 9, 1900, when the *Ventura Free Press* reported that the railroad was completed to Poindexter's ranch and that a depot was being built. This photograph, taken east of Moorpark around 1900, shows that railroad crews often had to use dynamite to blast away rock to create rail beds. (Courtesy Simi Valley Historical Society and Museum.)

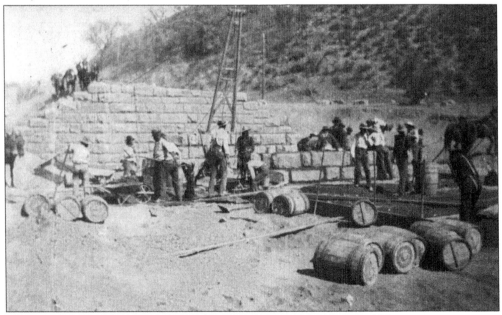

The Southern Pacific Railroad spared no cost to complete what would become its new main line. By July 1900, it had 2,000 men working to "close the gap" between Moorpark and Santa Susana. Blasting, grading, filling, compacting and leveling of soil, building bridges over the Arroyo Simi, and construction of culverts and retaining walls were all necessities for this grand project. (Courtesy Simi Valley Historical Society and Museum.)

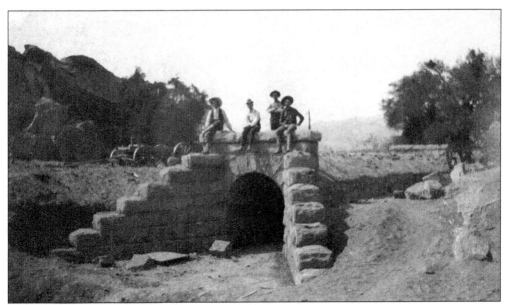

Backbreaking labor was required when laying rail and building trestles and culverts along the rail line. At the turn of the 20th century, when this photograph was taken, automobiles were a luxury that few experienced, especially when it came to moving heavy objects like these sandstone blocks. (Courtesy Simi Valley Historical Society and Museum.)

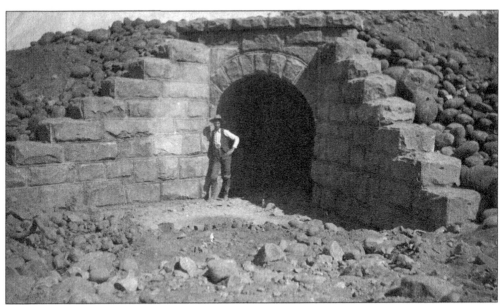

This photograph shows the completed tunnel that ran beneath the railroad tracks at the entrance of what is now Oak County Park, just east of Moorpark. Sandstone from the Santa Susana quarry, which is now a baseball field in the corner of Santa Susana Park, was used to build drainage culverts all along the main line between Moorpark and Santa Susana. (Courtesy Simi Valley Historical Society and Museum.)

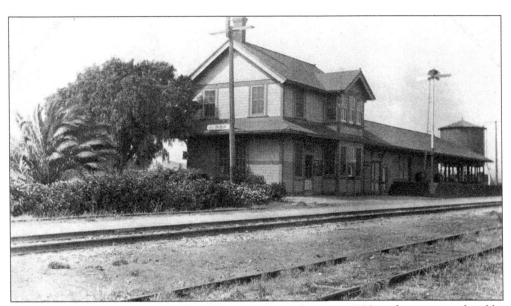

Work on the Southern Pacific Railroad depot in Somis began in 1899, and it was completed by the end of that year. The layout of the Somis depot was nearly identical to that of Moorpark's first depot, both of which were Standard Combination Depots No. 22L, the L indicating that the depot offices were located on the left-hand side of the building when looking at the depot from the tracks. (Author's collection.)

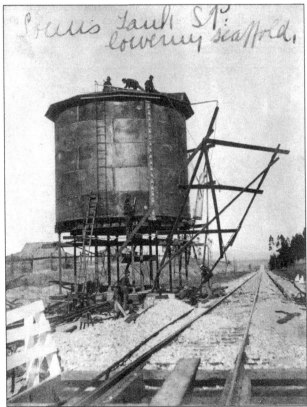

During the age of steam engines, water was the lifeblood of locomotives. Tanks were constructed all along the tracks so crews could fill their boilers as needed. This tank is nearing completion alongside the Somis depot in 1904. The spigot used for filling boilers can be seen beneath the scaffolding. Moorpark's water tank was located east of the depot and west of what is now Spring Road. (Courtesy Gwyn Goodman.)

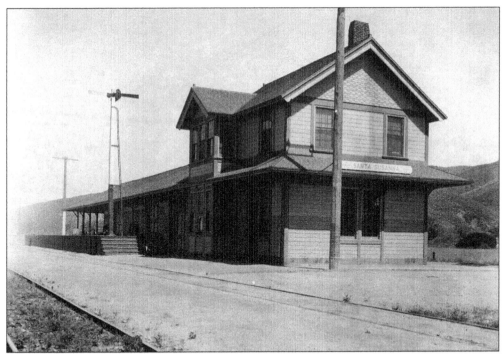

The Santa Susana depot, built in 1903, arose out of the need for a depot at the east end of the valley near the mouth of the proposed tunnel through the Santa Susana Mountains. The depot was originally located on Los Angeles Avenue and Tapo Street but was moved to Katherine Drive, where it was eventually restored and opened as a museum. (Courtesy Simi Valley Historical Society and Museum.)

Located just to the east of First Street, Simi's first station was a small building enclosed on three sides. The station had a separate freight platform, which can be seen in this photograph from October 1911. In 1916, after encouragement from the residents of Simi, a slightly larger station was built in the same location. (Courtesy Simi Valley Historical Society and Museum.)

As the laying of rail continued east from Moorpark, it entered the property of Robert P. Strathearn, who owned a large piece of the old Rancho Simi land grant. A loading spur, stock pens, and cattle chutes were constructed at a location that is now under the Madera Road overpass. This stop, named Strathearn Siding, was used for many years to transport both goods and livestock. (Courtesy Simi Valley Historical Society and Museum.)

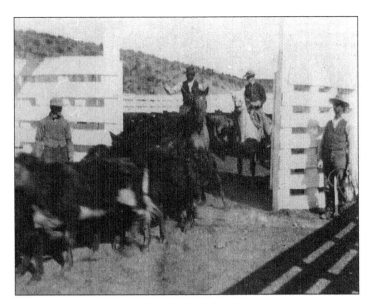

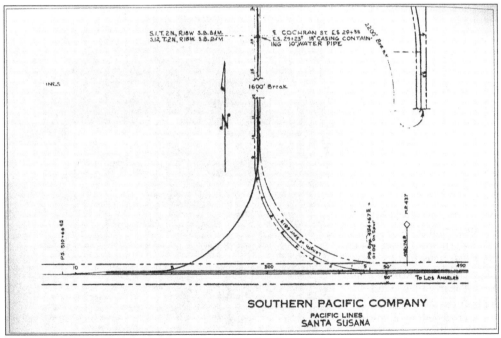

A wye track was built near what is now Tapo Road in Simi Valley so that southbound trains, prior to the completion of the Santa Susana tunnels, could turn around. Trains would head past the wye, back up until they cleared the eastern leg, and then move forward on the western leg to the main line and head towards Moorpark. (Courtesy Simi Valley Historical Society and Museum.)

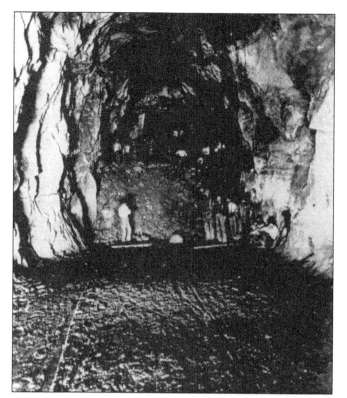

The longest of the three tunnels bored into the Santa Susana Mountains was tunnel No. 26, measuring 7,369 feet in length and begun on January 16, 1900. Digging commenced at both ends with parties eventually meeting only four inches apart in the middle. The first shaft served as the ceiling of the tunnel, and crews then removed the rock below to create the lower portion of the tunnel. (Courtesy Ventura County Museum of History and Art.)

Before the rail was laid so the first train could travel through the tunnel on March 20, 1904, crews had to give a clean finish to the rock walls, as well as install wooden support beams to attach to the arched ceiling members. A large rolling two-story platform called a Jumbo was used for this arduous task. (Courtesy Ventura County Museum of History and Art.)

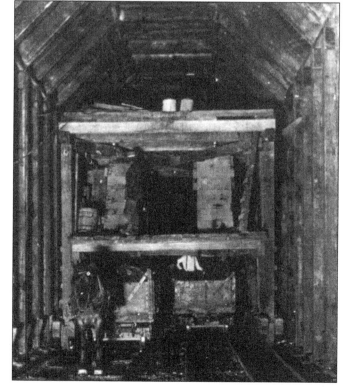

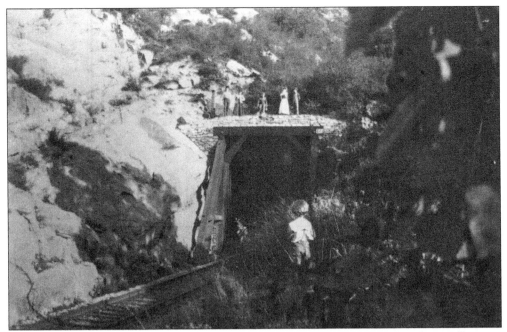

The Santa Susana tunnels, completed in 1904, were a feat of engineering and are still in use today. They also became a popular picnic destination where families could sit and watch the trains zoom in and out of both the east and west entrances. This picture shows the Dorn family of Moorpark taking an outing to the tunnels around 1905.

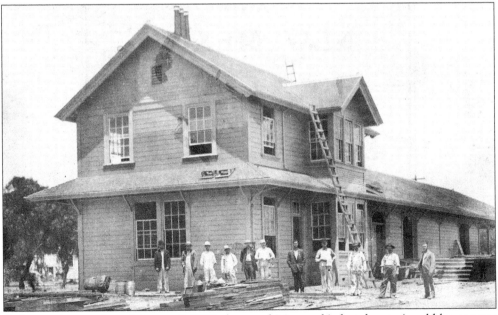

A fire on the evening of August 8, 1909, destroyed Moorpark's first depot. An old boxcar was set in place to serve as a replacement until Southern Pacific Railroad decided to finally begin construction of a new one in mid-1910. The new depot was essentially the same model as the first with just a few modifications. This photograph shows crews constructing Moorpark's new depot. (Courtesy Gwyn Goodman.)

Southern Pacific

SOUTHERN CALIFORNIA

ARIZONA

AND

NEW MEXICO

Corrected to August 1, 1911

SUBJECT TO CHANGE WITHOUT NOTICE

CHAS. S. FEE
PASSENGER TRAFFIC MANAGER
SAN FRANCISCO, CAL.

E. W. CLAPP
ASSISTANT GENERAL FREIGHT
AND PASSENGER AGENT
TUCSON, ARIZ.

F. E. BATTURS
GENERAL PASSENGER AGENT
LOS ANGELES, CAL.

F. C. LATHROP
DISTRICT PASSENGER AGENT
LOS ANGELES, CAL.

Southern Pacific Railroad frequently updated its timetables to reflect current fares, station stops, train schedules, and other useful information for travelers. In 1911, when this timetable was printed, the Shore Line Limited and the Lark could each get passengers from Los Angeles to San Francisco in 13.5 hours—one traveling during the day, the other by night. In 1937, Southern Pacific Railroad introduced its first streamlined locomotives to its Coast Daylight service. The GS-2 was a 4-8-4 steam locomotive and was the first to receive Southern Pacific Railroad's red and orange Coast Daylight paint scheme. Compared to the 1911 timetable, the GS-2 could shave more than three hours off the trip from Los Angeles to San Francisco, coming in at just under 10 hours. The Coast Daylight ran under steam power until 1955, long after other routes had converted to diesel locomotives.

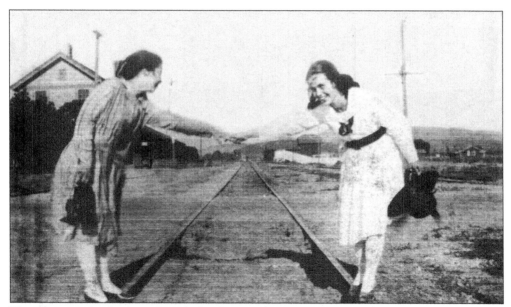

This photograph of two unidentified girls was taken around 1920 and gives a clear view across Moorpark Avenue looking east at the water tank located near Spring Street (now named Spring Road). The depot can be seen on the left, as well as stock pens and a cattle chute on the right. The large structure behind the stock pens is the Moorpark Walnut House.

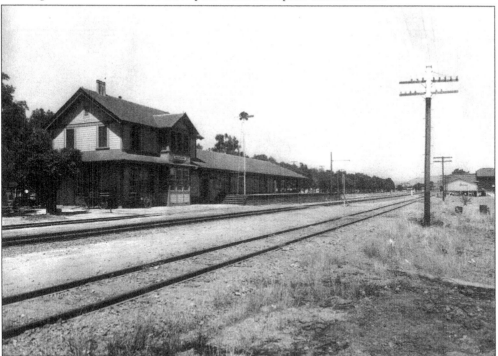

This trackside view of the Moorpark depot was taken in the 1930s. A Railway Express Agency (REA) sign is visible on the structure, as well as an REA cart in the left of the photograph. The REA was an express shipping service that served as a way for consumers to ship goods and packages throughout the nation. The REA ran from 1929 to 1975.

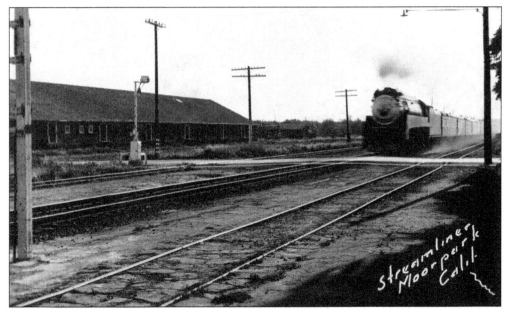

In 1937, Southern Pacific Railroad began its Coast Daylight train service from Los Angeles to San Francisco. This c. 1940 image shows a Southern Pacific streamliner heading east as it approaches the railroad crossing at Moorpark Avenue. The Southern Pacific Milling Company warehouse on the corner of Poindexter Road and Moorpark Avenue can be seen in the background. (Author's collection.)

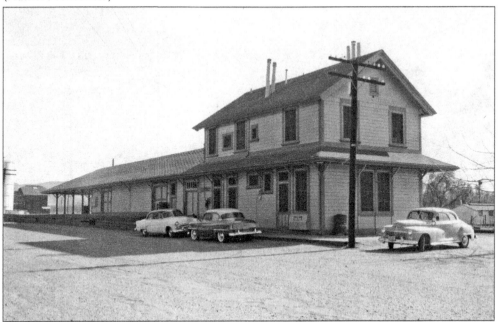

By the 1950s, the Moorpark depot had become a flag stop–only station, meaning that trains would only stop if there were passengers to be picked up or dropped off. Unfortunately, this was a reality for many stations nationwide due to the development of the Interstate Highway System and commercial aviation. Both of these provided alternatives for transportation and greatly affected both freight and passenger service. (Courtesy Bob Morris.)

Telegraphers played a vital role in the operation of the depot. They would receive vital train orders that would instruct engineers on how to proceed and of other train movements in the area. Orders would be written out and given to each passing train. This interior photograph of the Moorpark depot shows Ruby Williams sitting at her station in the depot office. (Courtesy Simi Valley Historical Society and Museum.)

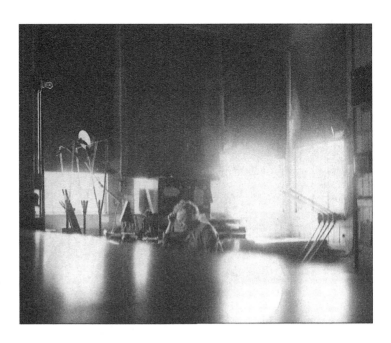

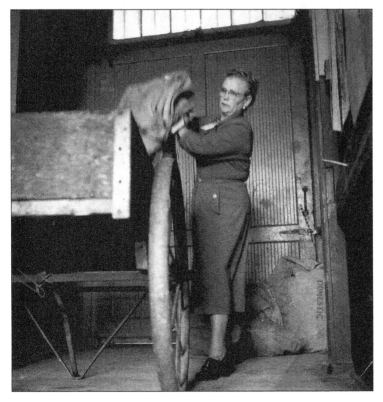

The application for the Moorpark Post Office states that the mail would not be delivered from another post office but rather by rail. For this reason, it became the daily duty of the station agent or telegrapher to sort mail that was dropped off at the station. Here, Ruby Williams sorts the day's mail delivery in the baggage room of the depot. (Courtesy Simi Valley Historical Society and Museum.)

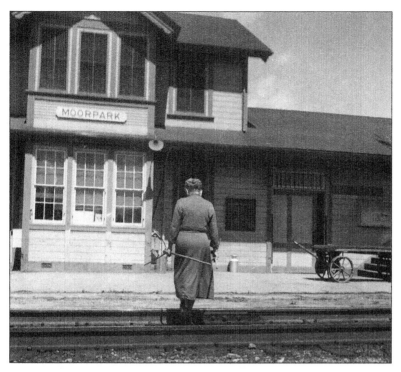

Train order signals were a staple at Southern Pacific Railroad stations/depots and alerted train crews if they needed to pick up orders. These large signals could tell train crews if they had orders or not, if they needed to stop, or if they could proceed. In this photograph, Ruby Williams returns to the depot with a discarded train order delivery fork. (Courtesy Simi Valley Historical Society and Museum.)

The protruding office of the standard model No. 22 depot made it possible for station agents or telegraphers, like Ruby Williams, to have a clear view of the tracks in both directions. Although train and depot crews worked to prevent accidents on the tracks, there are many instances in newspaper archives of pedestrians being killed or maimed by passing trains. (Courtesy Simi Valley Historical Society and Museum.)

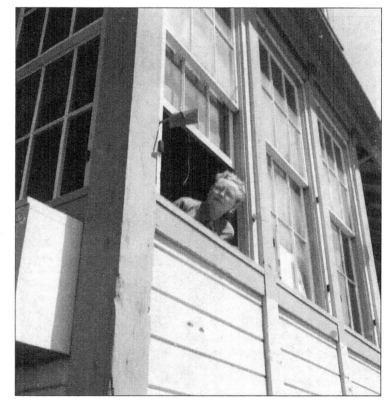

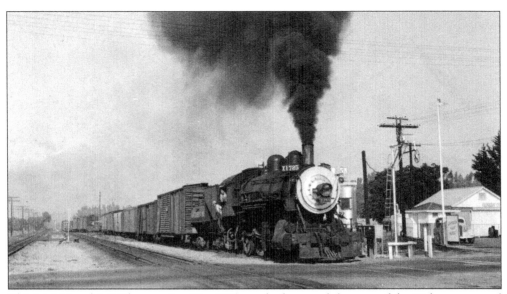

This M-6 Mogul 2-6-0 locomotive, No. 1785, was built around the turn of the 20th century and was one of hundreds sold to the Southern Pacific Railroad. Here, it is pictured facing east on a sidetrack at Moorpark Avenue, waiting for a passing train. After being retired and sold for scrap in 1958, it was purchased and restored by the Lomita Railroad Museum, where it is on display. (Author's collection.)

From the time it was built, the depot in Moorpark became the focal point of the community. Before the advent of the telephone, it was the depot that would receive reports of the latest news from around the state, nation, and world. The yearly Moorpark Arts Festival also used the depot to display art from local students, and residents of the town became very fond of the old structure.

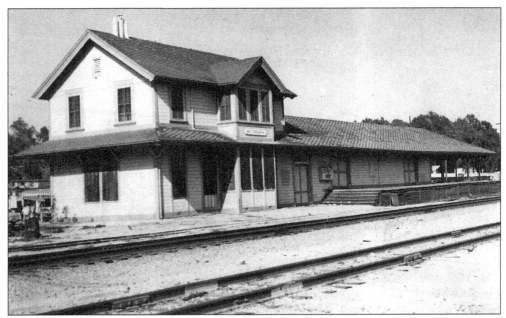

In 1958, the citizens of Moorpark were told that Southern Pacific Railroad would be closing its depot. Train stations and depots, like those throughout Ventura County, that were once so instrumental in hauling both goods and passengers, were now competing with other modes of transportation. It was not cost effective for the railroad to maintain these structures in small towns like Moorpark.

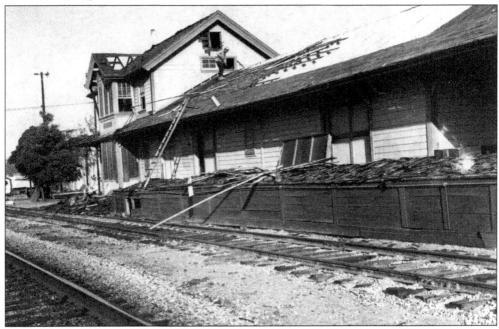

Although a group of residents fought to keep Moorpark's depot from being torn down, the Southern Pacific Railroad decided it would be in its best interest to raze it and reuse the depot property for other commercial ventures. The depot had been boarded up for a number of years and was becoming a liability for the railroad. The 54-year-old depot was demolished in December 1964.

Three

PIONEER FAMILIES

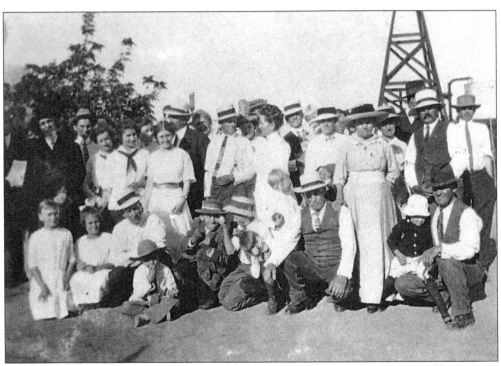

Pictured here is a Fourth of July celebration on the Solomon Gisler Ranch in 1914. For this particular celebration, guests got to observe a well being drilled on the ranch. In rural communities such as Moorpark, everyday mundane tasks such as this were celebrated, as they were an important and necessary part of life.

Aratus Everett was born in Michigan in 1845 and came to Montalvo in 1869 to work with an uncle. He purchased land west of present-day Moorpark in 1889 and planted apricot trees. He later purchased additional land and was soon operating one of the largest apricot orchards in the state. Aratus constructed a large apricot drying plant on his ranch to process his fruit.

In February 1875, Eva Parlina Gerry was united in matrimony with Aratus Everett in Saticoy. Eva, also born in Michigan, became the matriarch of a family with deep roots in the Moorpark area. Aratus and Eva had five children—Ernest; Edith, who married James Birkenshaw; Clarence; Louise; and Frank, who was the father of Monroe Everett.

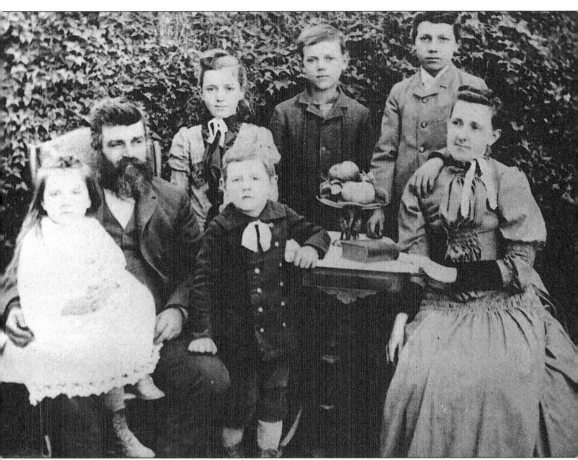

This c. 1890 photograph shows the Aratus Everett family as they appeared when they first arrived in Moorpark. They are, from left to right, (first row) Louise, Aratus, Clarence, and Eva; (second row) Edith, Ernest, and Frank. Louise, sitting on her father's lap, unfortunately passed away at an early age. The other children followed in their father's footsteps and worked with him on his large ranch. Clarence eventually became the proprietor of the north ranch, located on the north side of the railroad tracks. He specialized in raising hogs and sheep, as well as tomatoes and apricots. Edith married into the Birkenshaw family, which was another large ranching family in the area. Frank eventually received a share of his father's ranch on Los Angeles Avenue near Hitch Boulevard. Frank's son, Monroe Everett, also became a prominent rancher and his ranch, located in the Tierra Rejada Valley, was comprised of 75 acres of English walnuts, 53 acres of Valencia oranges, and 6 acres of avocados.

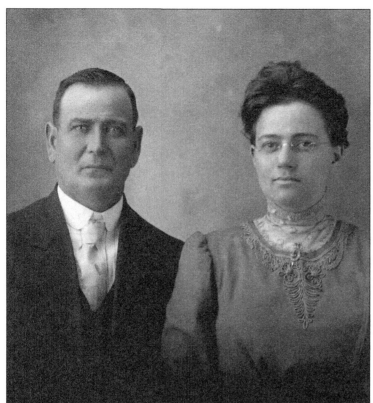

Listed in the 1898 Ventura County directory as residents of the Penrose district (the Fairview area north of Moorpark), James and Edith Birkenshaw were early settlers in the area. Edith was the daughter of another early farmer, Aratus Everett. James and Edith were married in 1909 and eventually built their large family home on Moorpark Avenue, which is still owned by the family. (Courtesy Jim and J.J. Birkenshaw.)

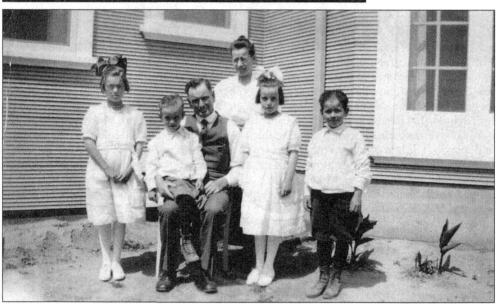

James and Edith Birkenshaw had four children—from left to right, Mary, George, Eva, and Howard. George and Howard carried on the family tradition of farming alongside their father in and around Moorpark. Howard eventually acquired the beautiful Spanish-style home that still stands on Los Angeles Avenue just east of Hitch Boulevard. The structure belonged to his uncle Clarence Everett. (Courtesy Jim and J.J. Birkenshaw.)

William Bauer and his wife, Serena, came to Moorpark around 1900 and purchased property from the town's founder and developer, Robert W. Poindexter. Bauer's ranch, located on the corner of Gabbert and Poindexter Roads, was planted with 60 acres of Placentia walnuts and 48 acres of hay and black-eyed beans. Bauer was also the first president of the Moorpark Walnut Growers Association.

The Hitch family was another clan from Tennessee that settled and ranched in Moorpark. In 1903, Archibald and Mary Hitch purchased a plot of land near where the Southern California Edison Substation is located today. After dryland farming beans for a couple of years, Archibald soon switched to apricots. In one year, he harvested and processed more than 300 tons of dried apricots.

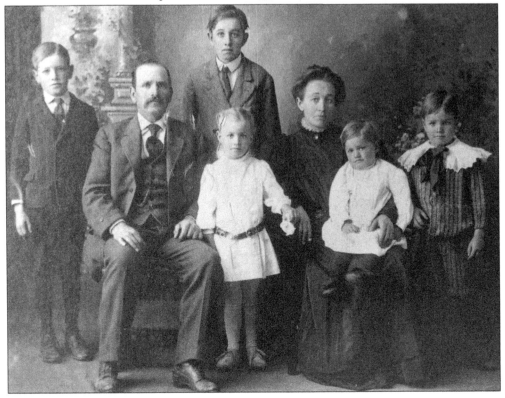

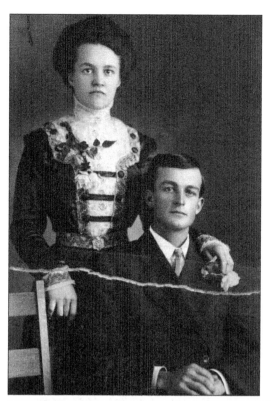

John Davis arrived in Moorpark from Marysville, Tennessee, in January 1903. He was greeted by friends Jake Keller and Jim Hitch, whom he knew from Marysville. Davis married his childhood sweetheart, Ellen Waters, and they purchased their ranch in the hills just west of town. John raised black-eyed beans, walnuts, and apricots. Ellen spent her time raising turkeys, which she sold during Thanksgiving and Christmas.

Seymour and Julia Munger came to town in 1904 to operate the Moorpark Hotel. Their four children are, from left to right, (first row) Marian, Claude, and Ruby; (second row) Leon. The children grew up helping their parents with the daily operations of the business. The hotel catered to businessmen passing through town and to train crews who would stop in Moorpark to enjoy a home-cooked meal.

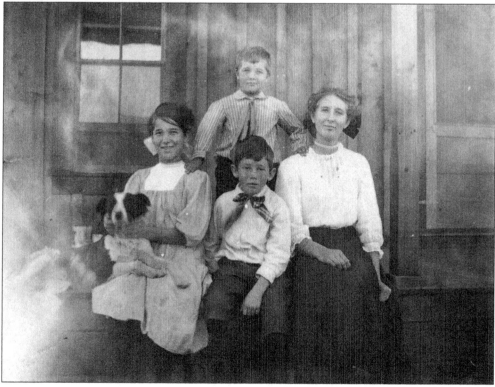

Charles Ide Dorn was an early businessman in Moorpark. He came to town in 1904 when he took over operations of the general merchandise store located on the northeast corner of High and Walnut Streets. Dorn became very involved in the community, serving as the postmaster and as a trustee of the elementary school. Dorn left Moorpark in 1908 to accept a position with the International Harvester Company.

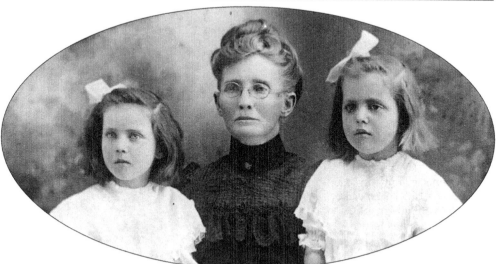

Minnesota Lemmon, the widow of a Texas cattleman, inherited property in Moorpark and was an important supporter of early commerce in town. Her bungalow, built in 1910 at the southwest corner of Charles and Walnut Streets, is still standing. She also built Moorpark's first drugstore in 1912 and rented the building to Dr. A. Holt. She is pictured here with her granddaughters Reita (left) and Jessie Balcom.

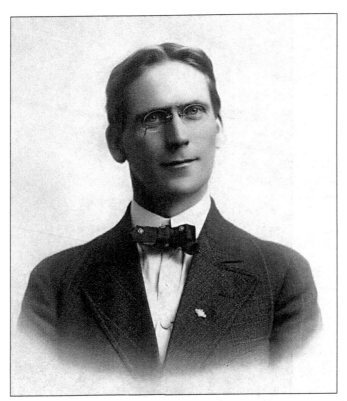

Austin Bernard "A.B." LeRoy was born in Canada and came to the United States around 1900. After residing in Somis for a few years, he began working at C.I. Dorn's general merchandise store in Moorpark in 1905. Three years later, he and Art Gillis purchased the store from Dorn and formed a partnership that lasted for eight years. (Courtesy Gwyn Goodman.)

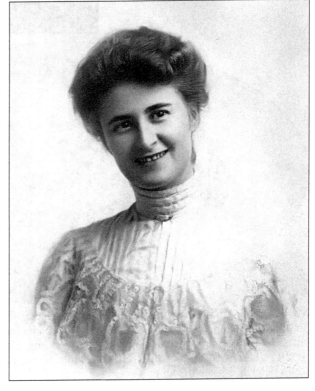

Janet Florence Hamilton was also born in Canada and came to the United States in 1905. That same year, she married A.B. LeRoy in Los Angeles, and they moved to Moorpark. Janet loved to work in the garden, and the LeRoy home, which is still located just east of the Mayflower Market on High Street, was known for its beautiful roses. (Courtesy Gwyn Goodman.)

John M. Cornett was born in Kentucky on April 4, 1866. In 1890, he is listed as a registered voter in California, residing in Saticoy. By 1910, John and his wife, Mary, were living in Moorpark on their 44-acre ranch on Poindexter Road, which they set out in walnuts. John and Mary's daughter, Dora, married Riley Spencer Sr. The Spencer family owned and operated a very successful grocery business in town for many years. (Courtesy Elizabeth Roe.)

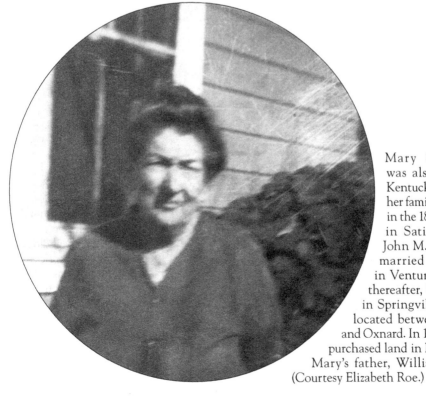

Mary Seeley, who was also a native of Kentucky, moved with her family to California in the 1880s and settled in Saticoy. She and John M. Cornett were married around 1895 in Ventura and, shortly thereafter, began farming in Springville, which was located between Camarillo and Oxnard. In 1907, the couple purchased land in Moorpark from Mary's father, William R. Seeley. (Courtesy Elizabeth Roe.)

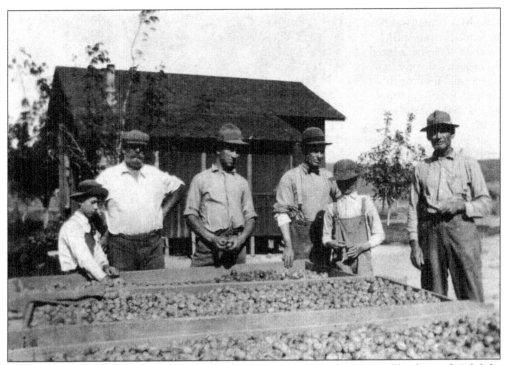

Solomon and Teresa Gisler came to Moorpark in 1910 with their sons Charles and Adolph. Their ranch was west of town, and they raised walnuts and lima beans. The family continued to farm until 1959, when most of their land was sold to developers, who built the Moorpark Estates housing tract. Pictured sorting walnuts are, from left to right, Charles, Frank, Emil, Solomon, Adolph, and an unidentified helper.

The Flory families settled in the Fairview district in 1911. There were two couples, Dave and Rose Flory and John and Katherine Flory. The two families farmed apricots, beans, and hay. In 1927, they sold a portion of their apricot and walnut orchard for the construction of the new elementary school, later named Flory Elementary. From left to right are Vera Flory Fulton, Jay Fulton, John Flory, and Rose Flory.

Manuel Duarte was born in Piru, California, in 1896 and came to Moorpark around 1913. He and his brother Eduardo leased the Balcom Ranch for a few years and raised beans, grain, and potatoes. Manuel and his wife, Pilar, raised 10 children in Moorpark, and many of their descendants still reside in town.

Manuel Duarte's brother Eduardo was another well-respected member of the community. Coming to Moorpark with his mother and siblings in 1913, he remained in town and became a lifelong resident. In 1921, he married Jessie Martinez, and he and Jessie's father were among the first large-scale tomato growers in this area.

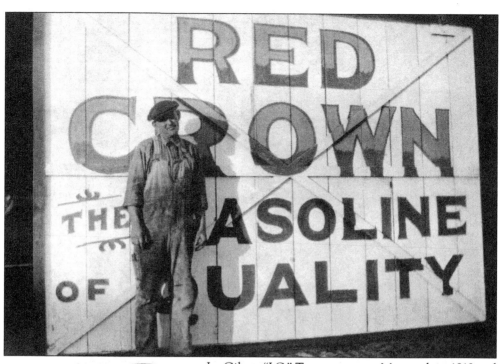

Ira Gilpen "I.G." Tanner came to Moorpark in 1913 and soon opened Moorpark's first auto repair shop, Mission Garage. Tanner was instrumental in the organization of Moorpark's first volunteer fire department in 1920 and became the town's first fire chief. He was very active in the community and served on the board of trustees when Moorpark Memorial Union High School was built in 1920.

Abbie Dingess was a graduate of the Boston Conservatory of Music and came to Moorpark in 1913. She became a respected and successful apricot grower and her ranch on "the mesa" (the Peach Hill area) contained over 1,000 apricot trees, other varieties of fruit trees, and walnuts. She is pictured here with her niece and namesake, Abigail.

Mable Bradley served as the voice of Moorpark's telephone switchboard for 27 years. After her husband's death, she was left alone to raise their five children. She settled in Moorpark in 1914 as the agent for the Moorpark Telephone Exchange, and the switchboard was installed in her house on Charles Street. In 1917, service was moved to the house at 209 High Street, where it remained until 1954.

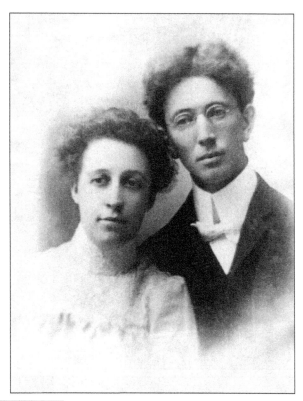

The David Linn Hendry family came to Moorpark in 1915 and purchased 50 acres of walnut property south of town. Hendry and his wife, Bessie, raised two children, Elliott and Miriam, on their ranch. Elliot graduated from the University of Southern California and worked for General Electric in New York until the Depression, when he returned to Moorpark and began to farm.

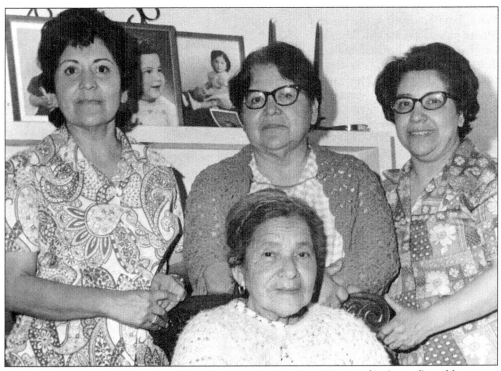

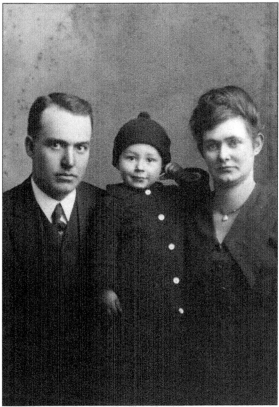

Petra Hernandez (seated) and her husband, Joe, came to Moorpark in 1916. Petra raised six children and built the first house on First Street. She and her husband were also the first Mexican American family to purchase land in Moorpark. Here, she is pictured with three of her daughters—from left to right, Esther Garcia, Carmen Perez, and Jennie Valenzuela.

Marysville, Tennessee, provided Moorpark with a number of early residents. This was the case with Mose and Nan Waters. Mose's sister was Ellen Waters Davis, wife of John Davis, and their uncle was Archibald Hitch. Mose and Nan came to Moorpark around 1919 and settled west of town where they purchased the Long Canyon Ranch. Their son Andy, pictured as a child here, also became a very prominent rancher.

Longtime Moorpark physician Dr. Frank A. Yoakam came to Moorpark in 1921. He was an acquaintance of the Whitaker family and lived with them for a short while when he first arrived in town. Dr. Yoakam's office and home, built on the southeast corner of Moorpark Avenue and Second Street, was constructed in 1925 and is still standing.

Robert and Minnie Davis arrived in Moorpark in 1922 from Marysville, Tennessee, and purchased their small ranch in Home Acres when there were only four houses in the area. Davis knew a thing or two about farming, having worked with his uncle Archibald Hitch. Although he set out some of his land in lemon trees, Davis also planted tomatoes throughout the Home Acres area.

On January 1, 1926, W.L. Whitaker took ownership of Hugh Reed's hardware and furniture business on High Street. In 1932, the furniture department was discontinued. Whitaker and his wife, Georgia, made Moorpark their home and were very active in the community. Along with his son Earl, Whitaker helped to build a thriving hardware business in town, and Whitaker's Hardware is still in operation today.

Joe and Juana Castro came to Moorpark around 1929. They purchased the building currently housing the Secret Garden restaurant and opened a market called La Mas Barata ("The Cheapest"). Their son Rueben, seated next to his sister Emily, became an advocate for the Latino community in Moorpark. He was honored in 2007 when the City of Moorpark named its new multi-agency center the Ruben Castro Human Resources Center.

Four

THE EARLY YEARS

Robert W. Poindexter's wife, Madeline, also played a role in the development of Moorpark. It appears that she and her husband split the landholdings that he received from the Simi Land and Water Company and that they shared ownership of the townsite. The map that this detail came from was recorded in December 1900. (Courtesy Ventura County Museum of History and Art.)

MAP
of a part of Tract 'L' of
RANCHO SIMI
Ventura County, California.
Showing the
Townsite of MOORPARK and Lands of
Madeleine R. Poindexter.
A resubdivision of Fremont Tract .
Compiled from Records
— Scale 10 Chains to 1 inch —

November, 1900

J. B. Waud
County Surveyor

RECORDED AT THE REQUEST OF .
Madeleine R. Poindexter
Dec 14 . A. D. 1900
at 30 min. past 10
o'clock A. M.
J. W. Browne
COUNTY RECORDER
By Jno J. Wagner
DEPUTY RECORDER

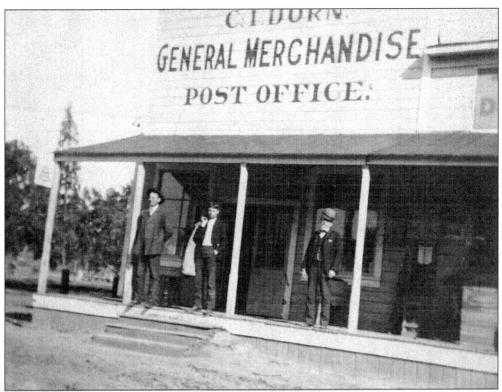

C.I. Dorn came to Moorpark in 1904 after purchasing the general merchandise store owned by J.E. Williamson, Moorpark's first merchant. The building, which was located on the northeast corner of High and Walnut Streets, was one of many that were moved from Fremontville by Robert W. Poindexter in 1900 as he was laying out the townsite of Moorpark.

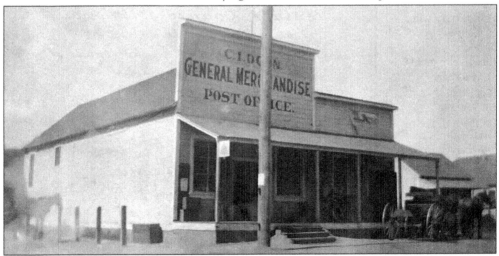

This view of C.I. Dorn's store shows Walnut Street on the left. Dorn was a progressive businessman and increased his stock to include a full line of groceries, hardware, and general dry goods. The telephone pole and public telephone sign hanging on the porch date this photograph to late 1908. The Moorpark Telephone Exchange was founded in October, and Dorn sold his business in November of that year.

BOUGHT OF

C. I. DORN

——Dealer in——

GENERAL MERCHANDISE

Salesman............ Moorpark, Cal.,190....

M._____

Bills Must be Paid Each Month

Creditor

By	doz. Eggs at			
By	lb. Butter at			

Debtor

	(handwritten)		
	(handwritten)	63	02

John Laughlin was an early farming pioneer in Fremontville, just west of Moorpark. In 1893, he purchased 130 acres and set them out in Santa Barbara soft-shell walnuts. A souvenir edition of the *Moorpark Enterprise* newspaper touts Laughlin's walnut orchards as one of the best moneymakers in Ventura County. The early years in rural Moorpark could be harrowing. In 1916, Laughlin lost his barn and its contents, including four prize horses, to fire. Before local merchants came to the area around 1900, Laughlin would have had to travel to Ventura, Oxnard, or Los Angeles to make large purchases of clothing and supplies. Local merchants helped to ease the burden on early residents. This receipt from C.I. Dorn's general merchandise store is dated June 22, 1907, and is for $63.02, which was a healthy sum considering it would be over $1,500 today.

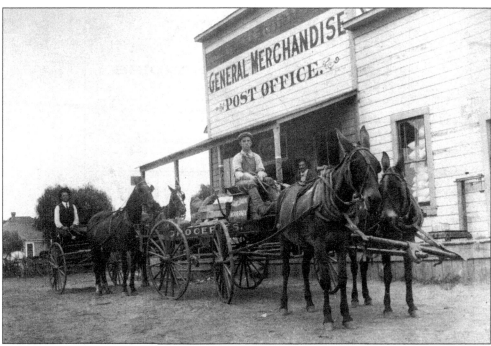

The two photographs on this page come from a small photo album that contains prints from eastern Ventura County that were taken in 1904. These photographs are perhaps the oldest documented images of Moorpark. The photograph above shows store owner Charles Ide Dorn (seated in the small buggy) and one of his employees, whose buckboard wagon is loaded with deliveries for residents. The image below shows Dorn, center, on the porch of his general merchandise store. Dorn can be found in records from Moorpark as early as June 1904. He sold his grocery business in 1908, when he moved to Los Angeles. Items on the porch include sugar, flypaper, canned goods, and other everyday household necessities. (Both, courtesy Gwyn Goodman.)

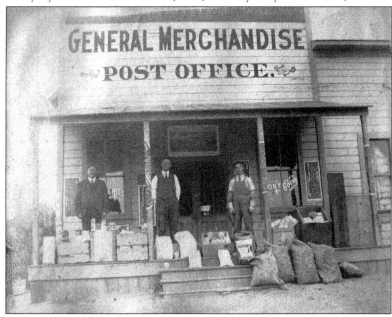

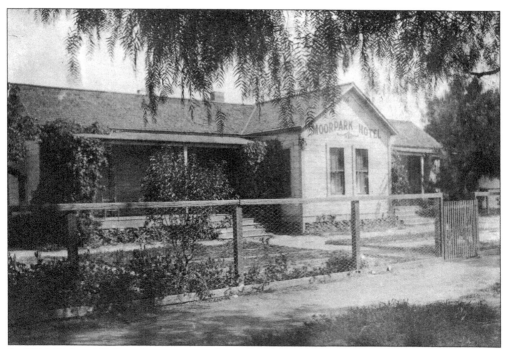

In 1900, Robert W. Poindexter arranged to have the Fremontville hotel building moved about a mile northeast to the corner of High and Bard Streets. Moorpark's depot was completed by March, so Poindexter was working to build up a town around the new station. In September 1900, he placed an advertisement in the *Los Angeles Herald* looking for someone to run his 10-room country hotel.

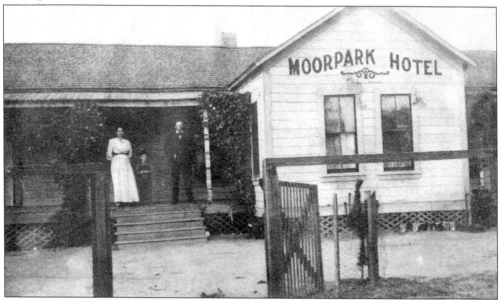

This early photograph of the Moorpark Hotel dates to about 1907 and shows Seymour and Julia Munger and their son Leon. The Mungers, who came to town in October 1904, were the first proprietors of the hotel and ran it until around 1908. Ownership changed hands many times throughout the 1910s, until the structure burned to the ground in January 1920.

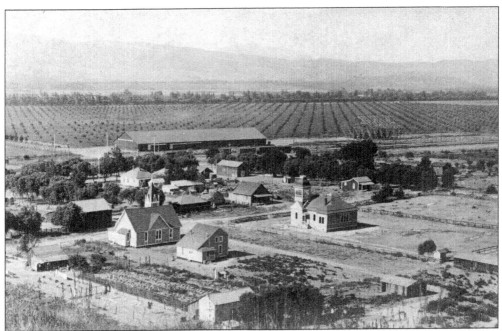

Taken between August 9 and October 13, 1909, this photograph represents the earliest-known overall view of the town of Moorpark. A prominent feature of Moorpark's landscape, the Southern Pacific Railroad depot, is missing in this photograph, as it was destroyed by fire on August 8 of that same year and not reconstructed until June 1910. (Author's collection.)

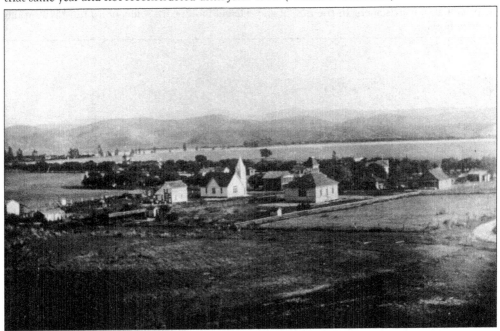

This is another very early view of Moorpark that dates from about 1910. This photograph is unique in that the view is looking in a more easterly direction than other existing views of town. The cross shape of the Moorpark Hotel, which was located on High Street near the corner of Bard Street, can be seen directly behind the roof of the church. (Courtesy Curran and Joy Cummings.)

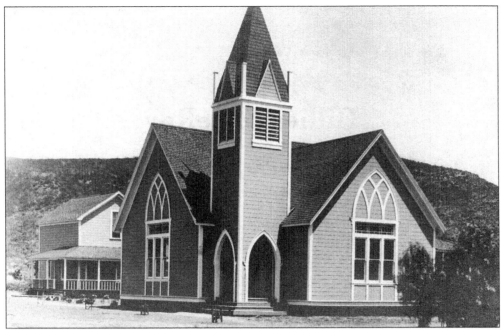

The moving of Wesley Chapel from Epworth to Moorpark began in late December 1906 and commenced in January of the following year. The new parsonage, shown alongside the church, was eventually moved to the east side of the building, where it still stands today. Archibald Hitch mailed a postcard identical to this one to his family in Tennessee on April 30, 1910. (Author's collection.)

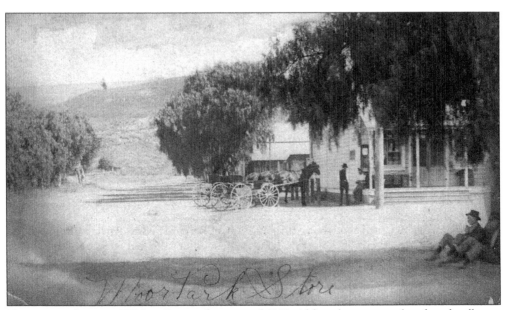

Here is an early view of Walnut Street taken around 1908. Although it appears that the schoolhouse and Methodist church are absent from this picture, they are just hidden behind the pepper trees that were planted as part of Poindexter's overall plan to improve and spruce up the townsite. (Author's collection.)

Moorpark, Cal., MAR 1, 1911 19___

M _____

Gillies & LeRøy

Dealers in

STAPLE AND FANCY GROCERIES

Boots and Shoes, Dry Goods, Notions,
Implements, Hardware

All bills paid by the 10th of the month following purchase will be
given 2 per cent discount, after 30 days 2 per cent int monthly

Balance Due 9 01

Moorpark merchants, such as Arthur Gillies and Austin Bernard LeRoy, provided an invaluable service to the early citizens of Moorpark. Poor road conditions, limited budgets, and primitive means of transportation made it difficult for rural inhabitants to shop anywhere outside of the immediate location where they lived. This was especially true during times of inclement weather when dirt roads would turn into mud and make travel virtually impossible. The introduction of the railroad helped to greatly improve transportation and residents could take the train into Ventura, Oxnard, or Los Angeles in the morning and return that evening. When this receipt was written in 1911, it was common practice for merchants to extend a line of credit to customers. This was especially useful for many of the local farmers who often needed to wait until their crops came in to have the cash to pay off their tab.

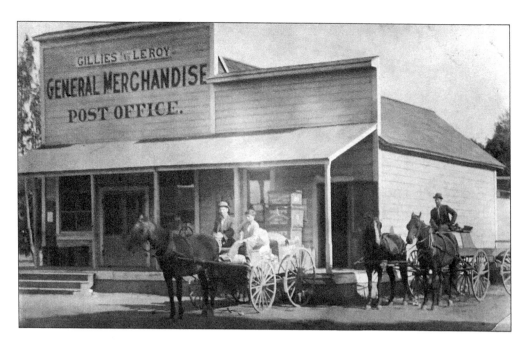

Arthur Gillies and Austin Bernard LeRoy went into business together when they purchased C.I. Dorn's general merchandise store in 1908. LeRoy, who began working at the store for Dorn in 1905, was very familiar with the business and the community. These two views show the store as it was between 1908 and 1915. The photograph above shows Gillies and LeRoy posing in the store's delivery wagons and is postmarked 1909. The photograph below is another view of the store, which also served as the post office. LeRoy was officially named postmaster in 1911 and held that position until 1915, when Moorpark's first postmistress, Yeteve Hull, was appointed. (Above, author's collection.)

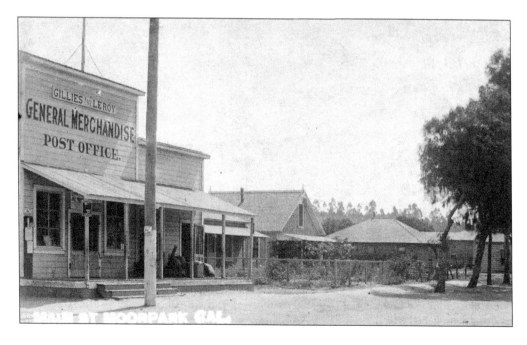

The Hoffelt building was the first two-story structure constructed in Moorpark. It was built by Michael Hoffelt around 1910 and was located on Moorpark Avenue at the west end of Charles Street. The building was used for many years for services by the Catholic Church, and in 1948, when Moorpark's newspaper began to rent out the space, it became known as the Enterprise Building.

The Moorpark Chapter of the Fraternal Brotherhood Lodge of America was organized in 1910. The organization spent $800 to build a hall that same year on the southeast corner of Bard and Charles Streets. In 1912, the hall was rented by the Moorpark Women's Fortnightly Club to house classes for the high school they had established in their clubhouse across the street. The hall was demolished in 1973.

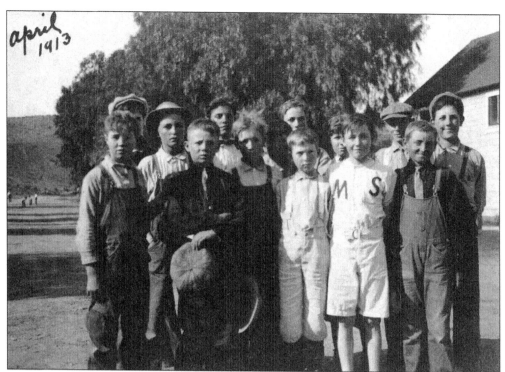

During most of Moorpark's existence, the historic center of town was the focal point for most all community gatherings and commerce. In the early years, most every business was located on High Street or Walnut Street, and both the school and Methodist church were located on Charles Street. The photograph above shows a group of Moorpark teens taking a break from play on Walnut Street in April 1913. The photograph below shows a celebration taking place on Walnut Street around 1915. It is clear in both of these photographs that the main roads in Moorpark had not yet been paved.

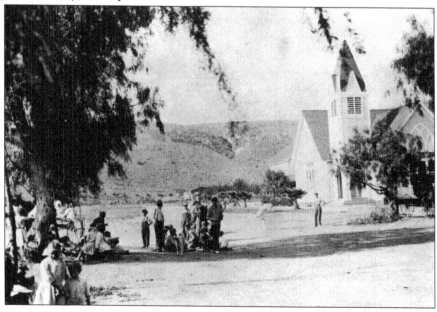

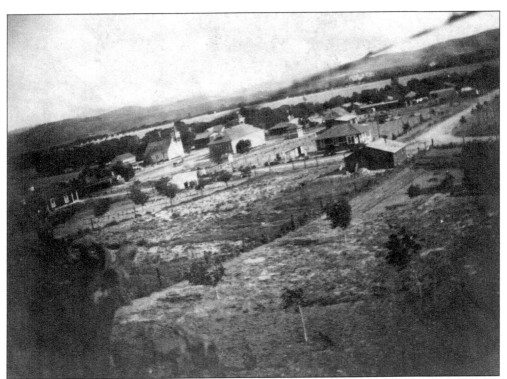

Here is another view looking southeast toward the town. Dated April 1913, this photograph provides a view all the way from Everett Street to the Arroyo Simi. Note that all of the land from the railroad tracks heading south to "the mesa" (the hill where Peach Hill, Mountain Meadows, etc., are located) is being used as farmland.

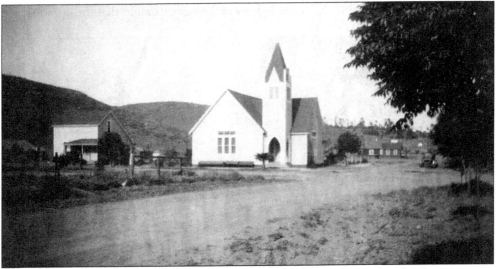

This 1913 view looking east on Charles Street shows how sparsely populated the town was in the early years. The large pepper tree in the far back right-hand side of the photograph was one of the original trees that the town's founder, Robert W. Poindexter, commissioned to be planted between 1902 and 1903. In the distance, one can see the newly constructed Moorpark Women's Fortnightly Club clubhouse.

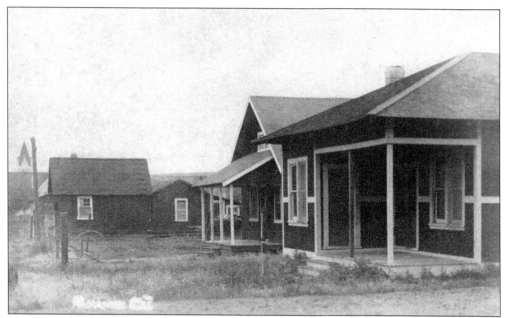

The Moorpark Women's Fortnightly Club was chartered in 1910, making it Moorpark's oldest service organization. As the population of the city grew, the members decided they should have a clubhouse where they could hold meetings and host civic functions. In 1912, they raised enough money to build a structure on Charles Street, where it still stands today as a family residence. This photograph was taken shortly after the clubhouse was completed.

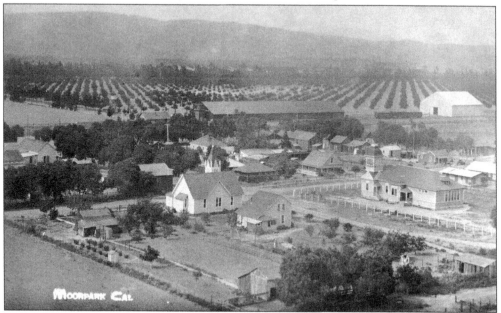

In 1912, larger enrollment prompted Moorpark school officials to issue a school bond. The schoolhouse was enlarged and can be seen in this c. 1915 photograph. Note also the two prefabricated buildings to the immediate right of the schoolhouse. Once the new elementary school was built in 1928, the North Side School, which catered to Spanish-speaking students, was housed in these buildings until the mid-1940s. (Author's collection.)

R.O. Mahan and family were pioneer ranchers in the Balcom Canyon area west of present-day Moorpark. The family grew beans and also raised cattle. Their son Art would also take trips to Nevada to round up wild horses and bring them back to the ranch. Once they were broken, he would sell them to local ranchers. (Courtesy Gwyn Goodman.)

The Comstock Ranch was located about two miles east of downtown Moorpark and was owned by A.B. Comstock, who was an early settler in the area. Comstock was a rancher and was listed as a member of the Fremontville School Board of Trustees in 1904. This 1914 Sunday school picnic on the ranch includes members of the Cornett and Binns families. (Courtesy Mark Trevor.)

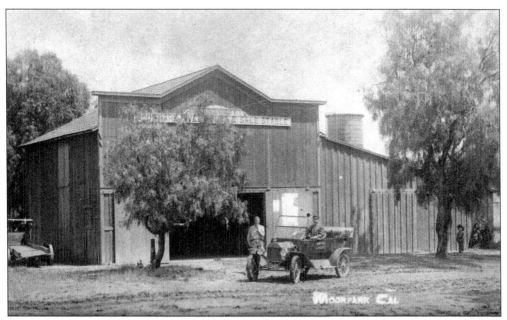

Moorpark's livery stable was owned and operated by Drew Gilliland for many years. In 1912, Gilliland sold his business to P.A. Honeycutt of Simi. When water was scarce, townspeople would use water from the well and water tank behind his stable. This photograph, taken around 1915, shows Honeycutt seated in his car outside his Moorpark Livery Feed and Sale Stable, located on the southeast corner of Walnut and Charles Streets. The other two individuals pictured are not identified. (Courtesy Gwyn Goodman.)

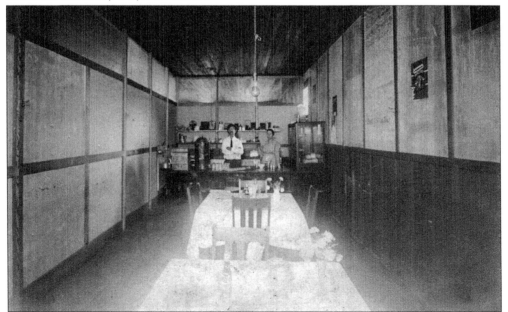

James Barrett's son Clarence, or "Crutch," was a year old when he came to Moorpark. He held many jobs while in town, working at the Feed Mill for over 20 years. In this photograph, Crutch is pictured with his wife, Ruby, in his father's restaurant on High Street around 1920. It was here on August 7, 1923, that Crutch's father received burns so severe that they caused his death.

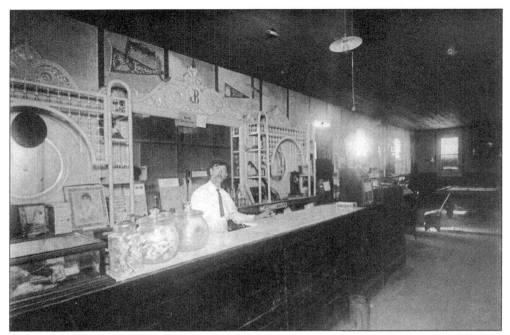

The Barrett family came to Moorpark in 1903, just as the town was beginning to develop its business section. Around 1913, James Barrett, pictured here, opened a billiards parlor on High Street. Barrett was industrious and also farmed, was a teamster, and owned a restaurant. A pennant pinned to the wall advertising a Fourth of July celebration in Los Angeles dates this picture to around 1914.

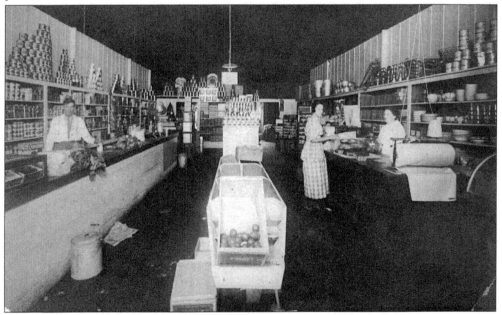

Robert E. Young, pictured at left in this photograph, was born in Kentucky in 1868 and came to Moorpark around 1912. He owned and operated a general merchandise store on High Street that was located just east of where the High Street Arts Center now stands. Young sold a variety of merchandise and had stiff competition in town as Gillies and LeRoy's store was less than a block away.

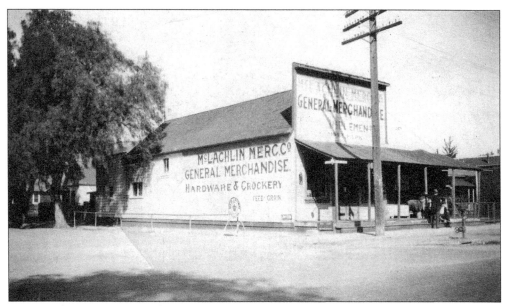

In November 1918, paperwork was filed in Ventura that transferred ownership of A.B. LeRoy's store to Fred McLachlin. LeRoy and McLachlin had been competitors in town since about 1915, when McLachlin first opened his business in Moorpark. This image, which shows paved streets, is the last known photograph of the store before McLachlin razed it and constructed a more modern building.

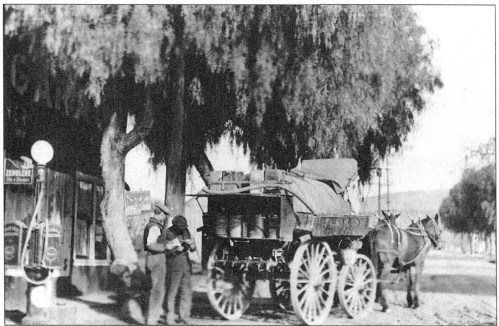

Since Moorpark was a rural community mostly made up of farmers, many citizens did not immediately switch from the horse and buggy to the automobile. Cars were expensive and could be very temperamental. I.G. Tanner provided early citizens of town and the surrounding areas a place to repair their automobiles and a place to fill them up with gas. Here, Tanner (right) accepts a shipment of gasoline around 1915. The deliveryman is not identified.

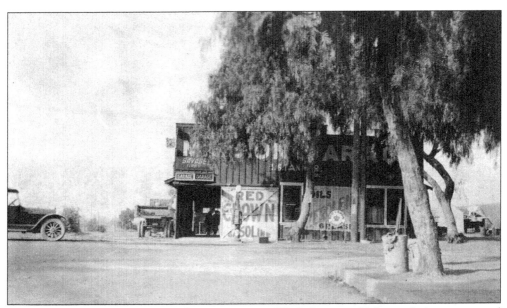

This is a view looking west across the intersection of High Street and Moorpark Avenue around 1916. Mission Garage, owned by I.G. Tanner, was Moorpark's first garage and gas station. By the time this photograph was taken, Moorpark's streets were finally paved. Tanner would eventually build the brick facade around his wooden structure, which still stands today.

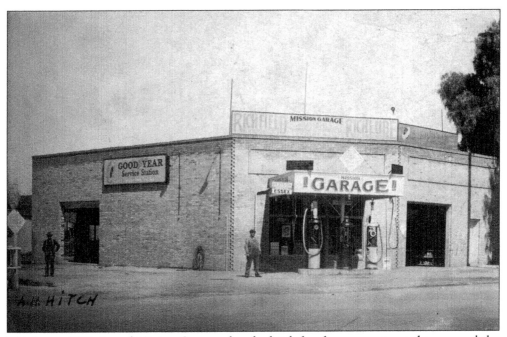

This is a c. 1917 view of Mission Garage after the brick facade was constructed to conceal the wooden buildings behind it. This structure, which is still located at the northwest corner of Moorpark Avenue and High Street, has been given the name Tanner's Corner over the years. In 2000, the building was added to the California Register of historical places.

Five

AGRICULTURE

This special souvenir edition of the *Moorpark Enterprise* was the brainchild of F.M. Puntenney and the Moorpark Chamber of Commerce. The idea was to spread the word about Moorpark's rich agriculture and the business opportunities that were available. Although this piece is not dated, the details behind its inception at a meeting of the Moorpark Chamber of Commerce are described in the March 3, 1916, edition of another local paper, the *Oxnard Courier.*

Apricots are a member of the prune family, and young trees will start to bear fruit after two to five years. In the spring, they will blossom, like these mature trees on the S.A. Williams Ranch in the Peach Hill area. The soft fruit is ready to harvest in the fall.

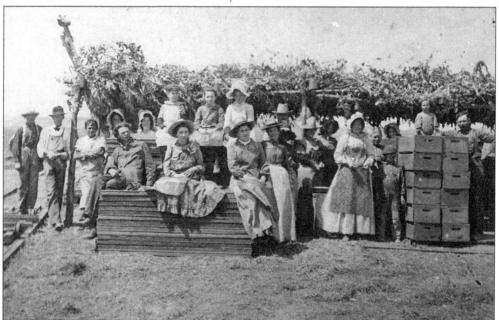

The process used by farmers in Moorpark to harvest apricots was first to have a crew shake the trees to release the fruit. Another crew would follow behind to pick it up and deposit it in 50-pound boxes. The fruit was then hauled to the fruit or pitting shed, where it would be placed on large wooden trays, then cut in half, and the pits removed.

72

The next step would be to lay the cut fruit halves cut side up on the trays. When full, the trays were placed on rolling fruit cars. The trays with the cut fruit were then wheeled into a smudge house where they were given four hours of sulfur fumes. The pits, or seeds, would be put on the cement floor where they would be exposed to the sun and dry. From the smudge house, the cars were wheeled to a nearby open area and the trays with fruit were spread out on the ground to dry, which would take several days. (Both, courtesy Gwyn Goodman.)

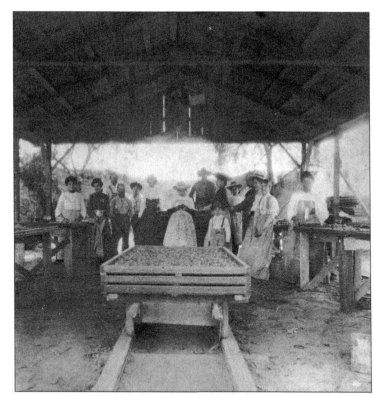

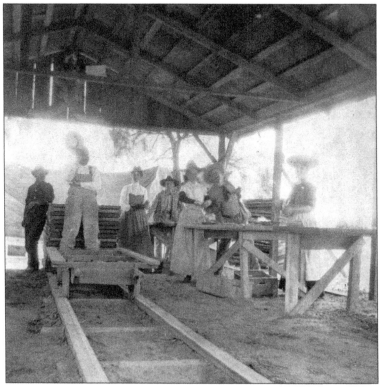

Once the apricots were completely dry, the trays would be stacked up again on each car. The dried fruit was then scraped by hand from the trays using a scraping tool and put into boxes so it was easy to handle and easy to sell. The trays were then returned to the fruit shed where they would be used again. Once the pits, or seeds, were dry, they were collected, put into sacks, and set aside so they could easily be handled or sold. This process was repeated multiple times a day at all of the apricot ranches throughout the fruit season. (Above, courtesy Gwyn Goodman.)

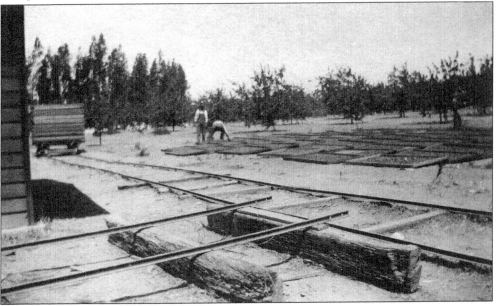

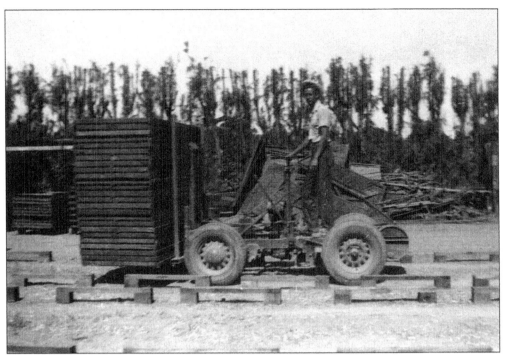

As technology advanced, hand fruit cars became obsolete and were replaced with motorized units that would perform the same task, only faster. This would improve sales and increase profits. This scene comes from the Wayne Everett Ranch, which was located on the former M.W.P. Wright Ranch, two miles outside of town.

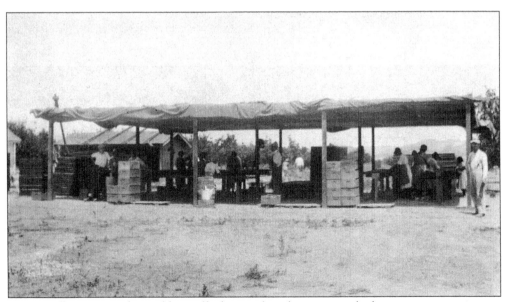

Some smaller growers who could not afford to purchase large pitting sheds or expensive equipment would resort to creating temporary, and oftentimes movable, structures to process their fruit. This wood-frame structure with a canvas top was not the most modern or high-tech solution, but it got the job done.

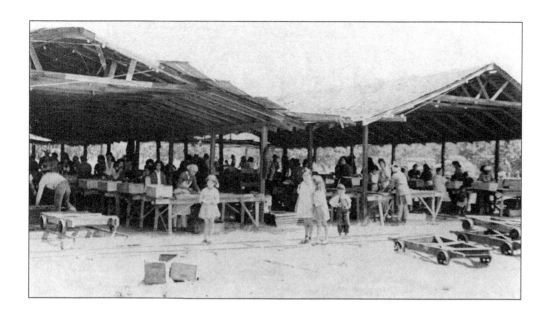

These two images represent another apricot season at the John Davis Ranch. The majority of the apricots processed in Moorpark and the surrounding areas were of the dried variety explained earlier. Another option was keeping the fruit fresh, but that required a canning facility nearby, which did not exist in the area. Apricots—like beans, hay, and barley, depending on the weather—could bear fruit with little irrigation. However, apricots, like all other fruits, did better when irrigated. By 1916, local businessmen had established the Moorpark Mutual Water Company and charged farmers a nominal cost to provide water for irrigation to their ranches.

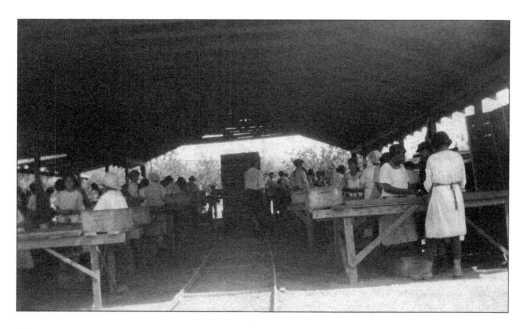

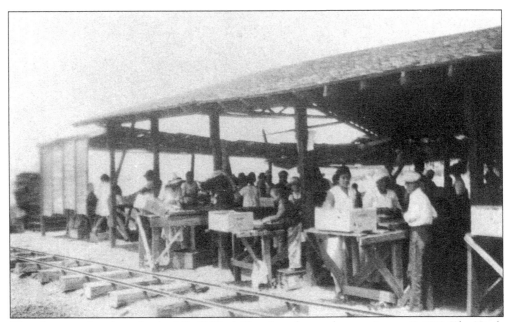

This photograph is from the Archibald Hitch Ranch and was taken on August 6, 1929. The Hitch family home, known as Hillcrest, was situated on a knoll just to the west of Moorpark High School. This spot provided the family with beautiful views of town and of their vast apricot orchards.

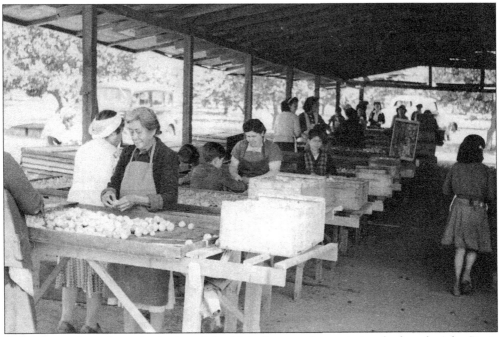

Petra Hernandez is shown in the front left of this photograph at a pitting shed on the John Davis Ranch. Harvesttime was an important time of year for people in Moorpark and other communities who relied on farming for their livelihoods. Because of this, it was not uncommon to see children visiting their parents and assisting however they could in processing the fruit.

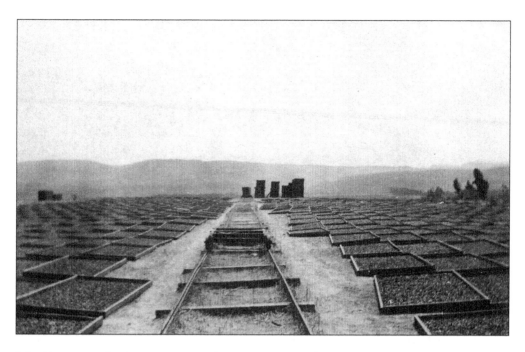

John Davis was a leader in apricot production in Moorpark. These two images of his operations show mature trees in the background, a pitting shed and sulfur house, parts of the elaborate cart and track system, and trays of fruit spread out as far as the eye can see. Once the fruit season began, it was important to have ample help to get the fruit picked and processed. Growers would create small villages of wood-floored tents to house the migrant workers who were hired to help with the harvest. In 1916, growers in Moorpark claimed that a return of $50 to $200 an acre, per year, was guaranteed for apricot production.

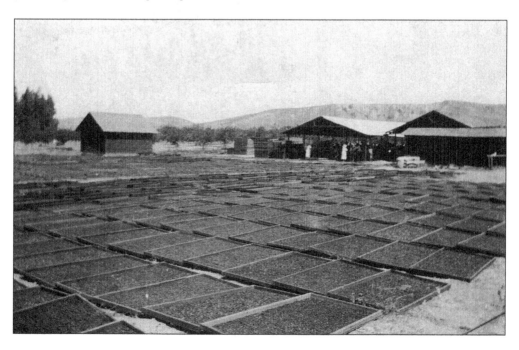

The Flory brothers were another family who were top apricot producers in Moorpark. Initially starting out in the Fairview area, they eventually moved into town and their apricot orchards lined Moorpark Avenue. These two images show their large pitting shed and the fruit that has been processed and is drying in Moorpark's arid climate. Ranchers in this area were fortunate that the apricot thrived as it did. Many trees lived to be over 30 years old and would still bear fruit. The apricot, unlike other fruit trees, grew well on steep slopes, rolling hills, and in the sandy, loamy soil of the valley bottoms.

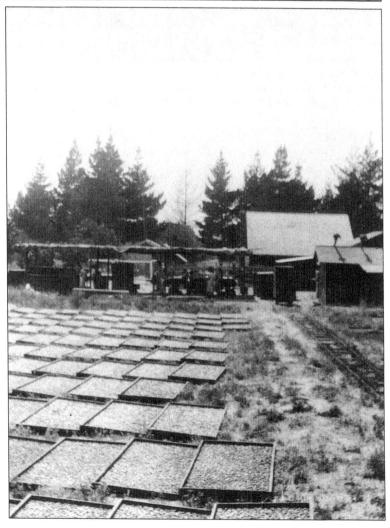

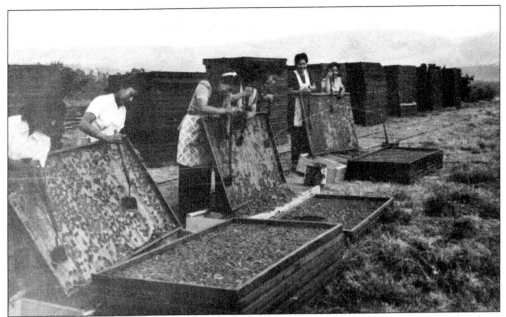

The process of scraping dried apricots from the wooden trays was an arduous task. The sheer number of trays that can be seen stacked up in the background of this photo gives an indication of the volume of dried fruit that the John Davis Ranch would process each season.

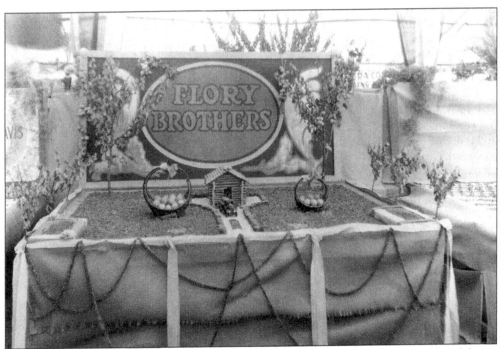

The Flory Brothers spared no expense in creating their display for the first annual California Apricot Exhibit held in Moorpark in July 1926. Their display contained a log cabin that was located in the center of a golden field of dried apricots with a background of green trees bearing ripe apricots.

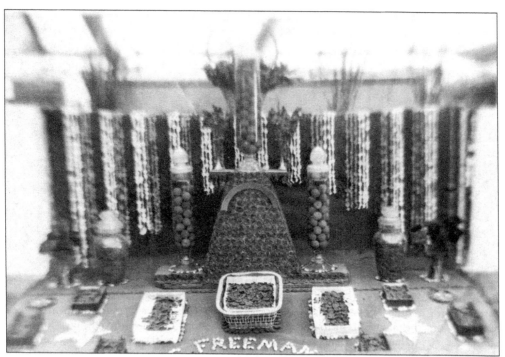

Agricultural displays, carnival features, and commercial exhibits were all part of Moorpark's first California Apricot Exhibit. A 175-by-150-foot tent was erected in town to house the event. According to event organizers, it was the first ever exposition in the state devoted solely to apricots. The Freeman Ranch, whose six-by-nine-foot display is pictured, won first place in the dried fruit category.

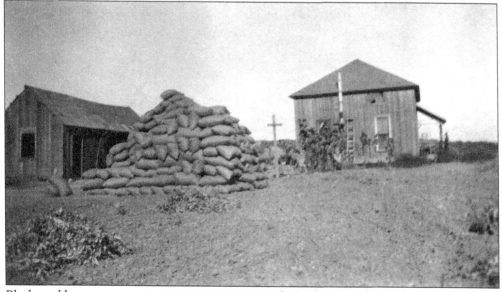

Black-eyed beans were grown in great quantities on the Mahan Ranch, which was located west of town in Balcom Canyon. Beans needed to be sown after all danger of frost had passed and when the soil was warm. This crop was very drought tolerant so it was a perfect choice, as it did not need to be irrigated often. (Courtesy Gwyn Goodman.)

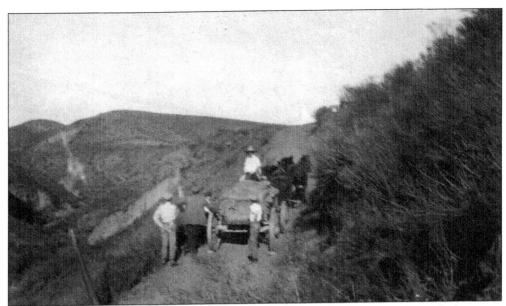

Farmers living in rural areas could have a very challenging time traversing narrow and often steep roads cut along the many hills surrounding Moorpark. For downhill trips with a heavy load, it was often necessary to harness the horses to the back of the wagon to provide resistance to ensure a slow and steady descent. (Courtesy Gwyn Goodman.)

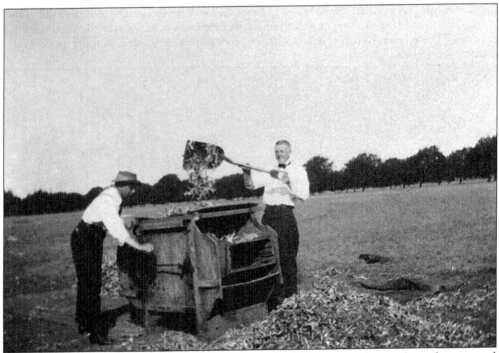

Emil Gisler, pictured at left, is shown working with a friend to run beans through a manual fanning mill. Fanning mills were most often used to remove straw, dirt, dust, rocks, and other contaminants from beans, wheat, oats, rye, barley, and other grains. This photograph, taken around 1910, shows Gisler's five-year-old walnut trees in the background.

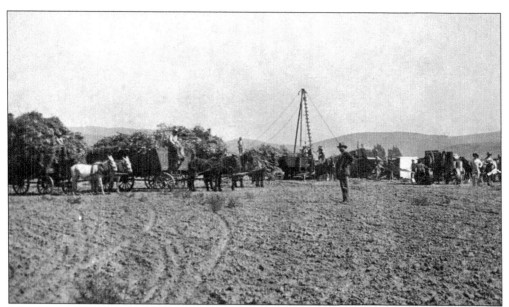

John Cornett owned and farmed the area south of the railroad tracks, which is known today as the Walnut Acres and Vista Verde subdivisions, located just north of Los Angeles Avenue. Cornett, pictured on the right with his threshing crew, had 140 acres in this area and raised beans and walnuts.

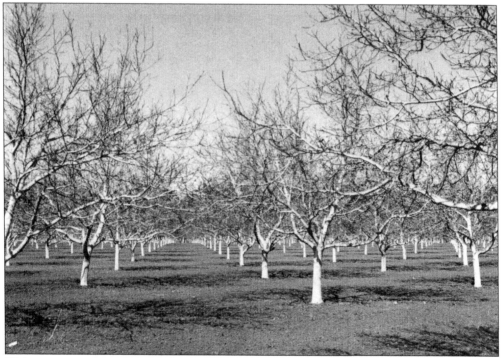

Walnut trees, such as these on the Monroe Everett Ranch, grow best when planted in deep soil and in a location that provides plenty of direct sunlight. The combination of the soil and climate in Moorpark proved to be perfect for walnut cultivation. These trees are still living and are located on the Brecunier Ranch. This orchard is used as a venue for special events.

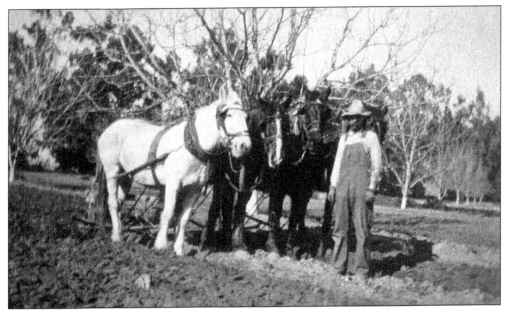

Frank Everett, the father of Monroe Everett, is pictured here with his four-horse team tilling the soil in his walnut orchard near Hitch Boulevard. In 1915, a total of 210 tons of walnuts went through the warehouse at Moorpark and brought growers $50,000. (Courtesy Rick and Linnea Brecunier.)

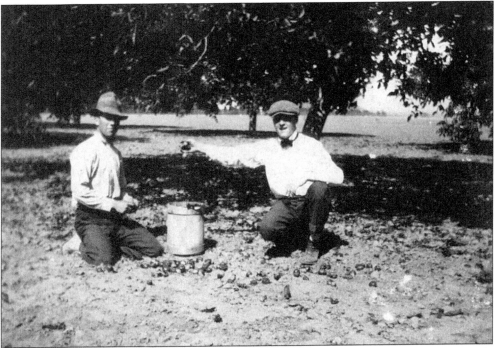

Emil Gisler, pictured at left, picks up walnuts with a friend in the Gisler family orchard. Early walnut cultivation in Moorpark started with workers using long wooden poles fitted with a hook to shake walnuts loose from the trees. Walnuts were then collected, dried, and hulled before being sent to market.

This is another scene from the Gisler walnut orchards. Harvesting walnuts in the early years, before mechanization, was very difficult and required a large workforce. With the advent of technology, tractors were incorporated and could be used to shake the trees, arrange the walnuts into rows, and collect them into a hopper.

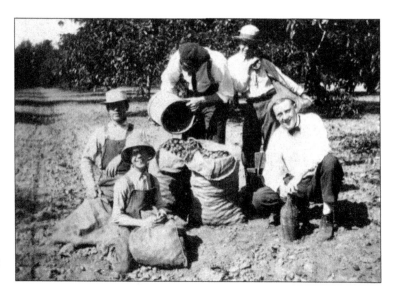

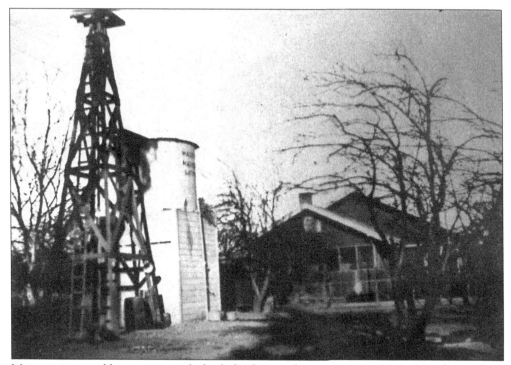

Maintaining a viable water source for both drinking and irrigation was a top priority for ranchers. This view of the Everett house on Hitch Boulevard shows the progression from wind collection by use of the windmill to mechanized collection through the use a gas or electric pump, which was located in the pump house below the water tank. (Courtesy Rick and Linnea Brecunier.)

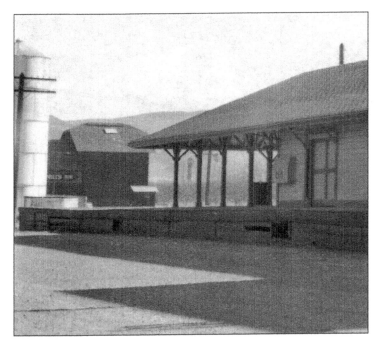

In 1915, a number of walnut growers in Moorpark banded together in order to market their crops more profitably. They named their organization the Moorpark Walnut Growers Association and became affiliated with the California Walnut Growers Association. The initial cost for the building and equipment came to $5,000, and the organization thrived in Moorpark for 42 years. The walnut house was located east of the depot.

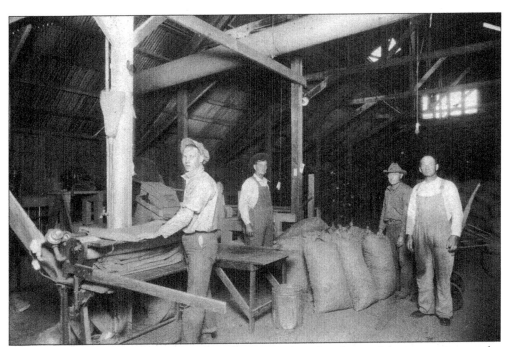

An interior view of the Moorpark Walnut Association's packinghouse shows operations on the structure's second floor. After sorting and grading, walnuts were sent to the bagging area where they would be put into burlap sacks that notated the grade given to the fruit. The walnuts would then be stored to await shipment to customers. Since the walnut house was alongside the railroad tracks, walnuts could be shipped very quickly.

Honeybees play a necessary and often underappreciated role in agriculture. Pollination of plants is the act of transferring pollen grains from the male anther of a flower to the female stigma. Without pollination, plants will not reproduce, and bees are natural pollinators. Mobile apiaries, such as the one pictured above belonging to Orville Peer, could be rented by ranchers and moved to any location to provide pollination services. Peer's apiary was located in the Fairview area, and boxes would be housed there during the winter months and when not in use by a local farmer. An added benefit to having an apiary is the perk of extracting and selling honey.

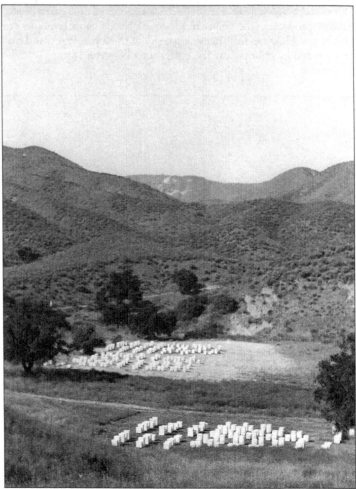

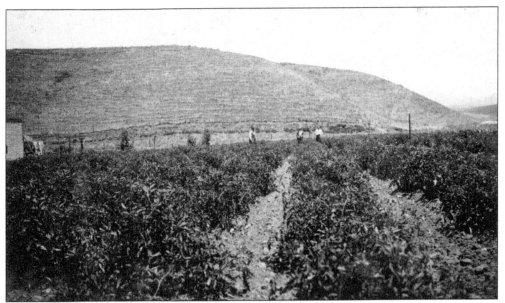

Tomato production took place in Moorpark but on a much smaller scale than for apricots, walnuts, and beans. Elwayne Torrance was a resident of Home Acres, and his tomato patch, pictured here, was located in what is now the buffer zone between Home Acres and the housing development to the east.

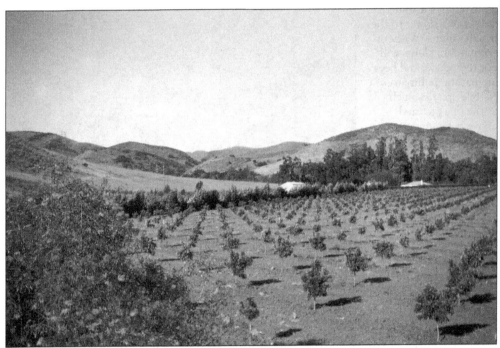

Monroe Everett had great success with the orange trees, shown here as saplings, that he planted on his Tierra Rejada Ranch. Citrus production, which required regular irrigation, improved when the Moorpark Mutual Water Company installed a 20-inch water main within one mile of town. (Courtesy Rick and Linnea Brecunier.)

Six

SCHOOLS

By 1913, Moorpark's schoolhouse had been moved from "the mesa" in Peach Hill to the corner of Walnut and Charles Streets. It had also been enlarged due to a school bond that was passed the previous year. This souvenir from principal Mary W. Cornett lists the names of all 44 pupils who attended school that year.

PUBLIC SCHOOL
Moorpark, Ventura County, California
MARY W. CORNETT, Principal
MAYE S. LARGE, Primary
Jas. E. Reynolds, Co. Supt.
Trustees
J. H. Barrett J. M. Cornett
A. Hitch
PUPILS

Eugene Barrett (8th Grade) Eva Flory
Viola Boring Clarence Estes
Virgie Cornett Joe Gnidotti
Ernest Marsh

Johnnie Cornett (7th Grade) Paul Hitch
Chester Estes Hugh Sisson
Anna Heuer Rupert Snuffin Roy Sisson
Sixth Grade
Myrtle Salisbury Robert Wright
Fifth Grade
Hazel Barrett Ellery Colston
Walter Bauer Clayton Welch
Dora Cornett
Charlie Bauer (4th Grade) Floyd Estes
Jack Snuffin Ruth Salisbury
Third Grade
Clarence Barrett Willie Bauer
Alice Binns Helen Binns
Ruby Cornett Harris Hitch
Rosella Welch
Maggie Hitch (2nd Grade Ira Welch
Ada Boring (1st Grade Ida Boring
Chester Barrett Dorothy Barrett
Floyd Binns Wayne Everett
Sarah Honeycutt Sammy Hitch
Verna Salisbury Vesta Dickerson

89

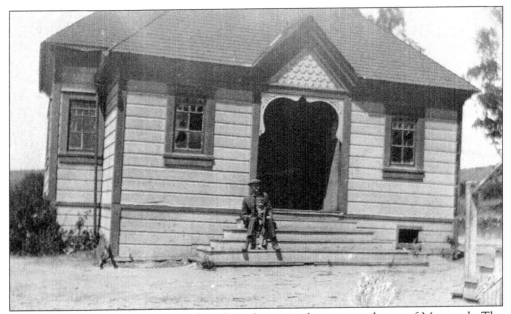

The Fairview School District served students living in the area northwest of Moorpark. The Fairview schoolhouse was located where Broadway dead-ends into Stockton Road near the Waters' Ranch and was completed by December 1891. The name *Fairview* is said to have been coined because, on a clear day, residents had a "fair view" of the ocean.

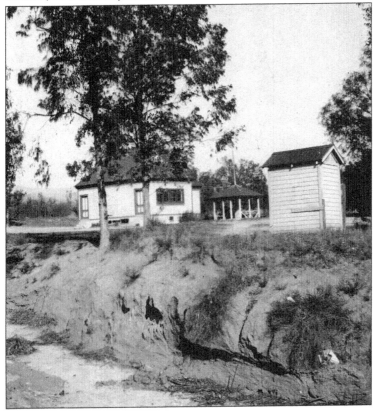

In the early days, modern conveniences were not a part of growing up in Moorpark and the surrounding area. During the rainy season, flash flooding from rain runoff could swell small streams that were usually dry and create very dangerous situations. This rear view of the Fairview schoolhouse shows a dry streambed running alongside the school and the girls' privy, or outhouse.

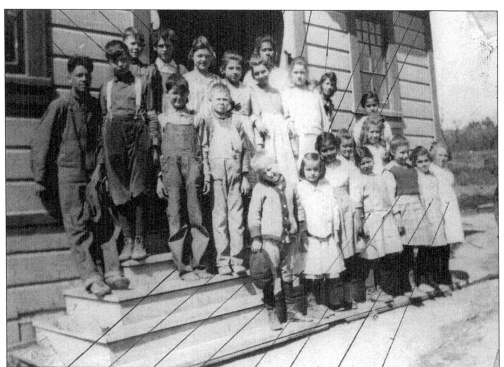

Like most rural one-room schoolhouses, the school at Fairview catered to students of all grades, from first through eighth. This can be seen in this 1918 picture showing the student body standing at the entrance of the school. These students represent some of the area's earliest farming families and include children from the Birkenshaw, Delaway, Everett, and Kerr families.

Mary Willard arrived as a teacher in Fremontville when the schoolhouse was still located in Peach Hill. She taught there for one year and later served as principal after the schoolhouse was moved to Moorpark. She eventually married Frank Cornett and they purchased the Munger house, which was located across the street from the schoolhouse on Charles Street near Moorpark Avenue. Mary and Frank also opened a meat market in town and provided delivery service to local residents.

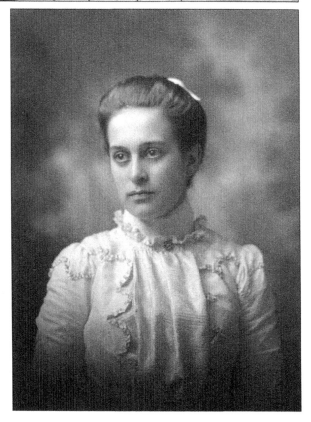

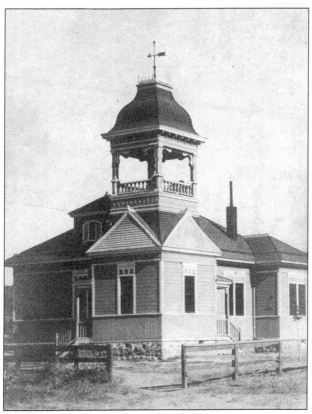

In March 1904, the residents of Moorpark petitioned the Ventura County Board of Supervisors to change the name of their school district from Fremontville to Moorpark. By August of that year, the name change had been approved and the schoolhouse was being moved to the center of town at the northwest corner of Charles and Walnut Streets. This photograph was taken around 1910.

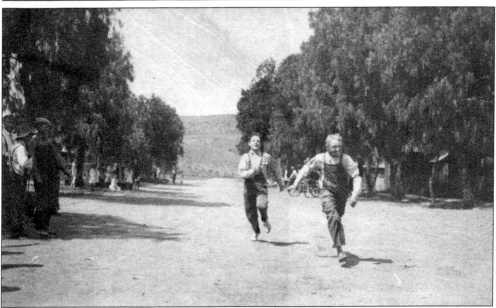

Recess time at school included spending time with classmates, as well as playing on the school grounds and on the streets surrounding the schoolhouse. This 1913 photograph shows students from the grammar school participating in a footrace. They are heading south down Walnut Street towards High Street.

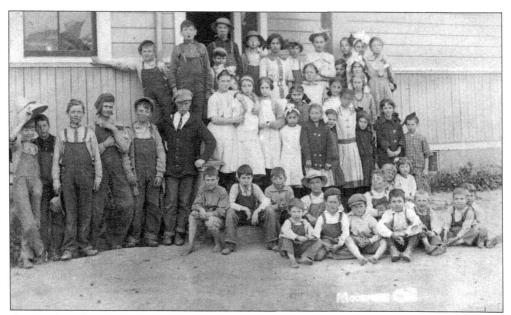

A second teacher was added by 1912 to help with the increasing number of students being served by Moorpark's schoolhouse. Instructors were responsible for teaching multiple subjects to students in each grade level. The schoolhouse not only served the students of Moorpark, but was also used for community gatherings and even to hold Sunday school classes before the Wesley Chapel was moved into town.

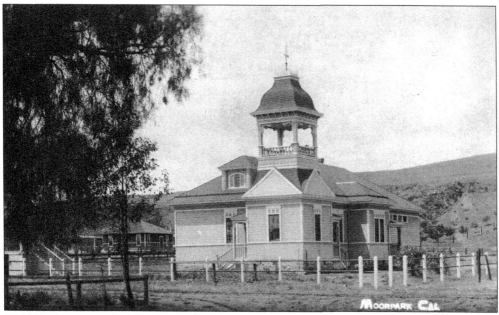

By 1912, the aging schoolhouse was found to be too small to accommodate Moorpark's growing number of students. A bond election was held that year and voters approved $2,500 for school improvements. By October, the work on the schoolhouse was nearly complete. This photograph shows the schoolhouse after it was enlarged and a covered lunch pavilion was added.

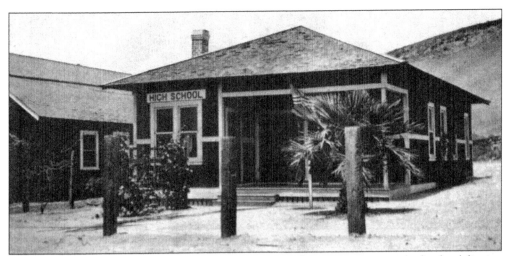

As early as 1909, the citizens of Moorpark began to petition the county to create a high school district. When their requests were not answered, community members created their own private high school. In 1912, the Moorpark Women's Fortnightly Club provided use of its clubhouse on Charles Street free of charge, although each of the 10 students had to give $10 a year to pay for the teacher.

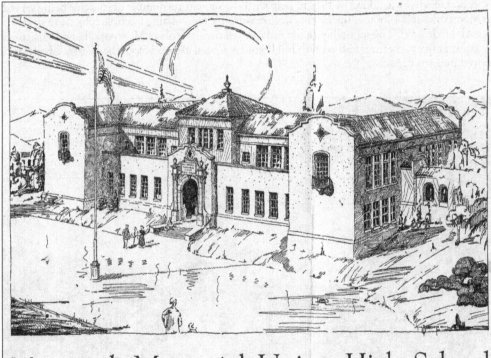

Moorpark Memorial Union High School

In February 1920, voters approved an $85,000 bond for construction of the Moorpark Memorial Union High School. The location chosen for the school was a beautiful knoll northwest of town. A laying-the-cornerstone ceremony was held on October 30, 1920. Items placed inside the cornerstone before it was sealed included the school's first game-used baseball and a picture of the grounds before the school was built.

Architect M. Marston of Los Angeles designed the beautiful Mission-style structure for Moorpark's new high school and ground was broken on July 21, 1920. Community workdays were held throughout the construction, and residents were encouraged to lend a hand to expedite its completion. Forty-two students moved into the structure to begin classes before it was even completed. (Courtesy Moorpark Unified School District.)

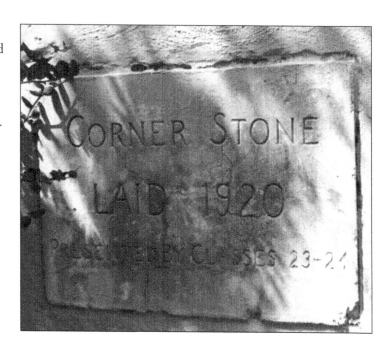

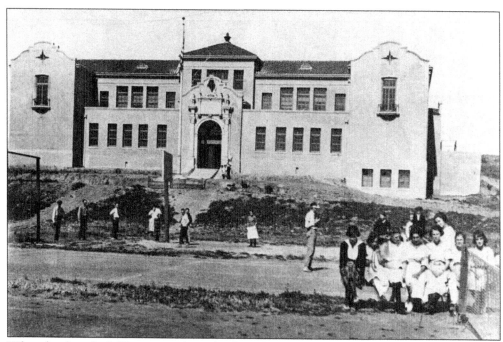

"The school on the hill" was something that brought a lot of pride to the community, and students from all parts of the county made the trek to Moorpark to attend classes here. Lucille Mitchell holds the distinction of being the first and only graduate at the school's first commencement exercises on June 16, 1922. The graduating class the following year numbered 10 students.

Moorpark Memorial Union High School

Moorpark, California

Be it known that **Margaret Alberta Howland** has completed Satisfactorily the course of Study prescribed for Graduation from this High School and is therefore awarded this Diploma In Witness whereof we have affixed our signatures this twelfth day of June in the year One thousand nine hundred and twenty-four

David S Hendry
President, Board of Trustees

James H. Fitch
Secretary, Board of Trustees

Claude L. Reeves
Principal, High School

The citizens of Moorpark lobbied for nearly 10 years to get permission to build a public high school in town, which served students in the Fairview and Long Canyon school districts. To ensure students had a way to get to school, the district purchased a bus in 1921. Alberta Howland's diploma from 1924 puts her in the school's third graduating class.

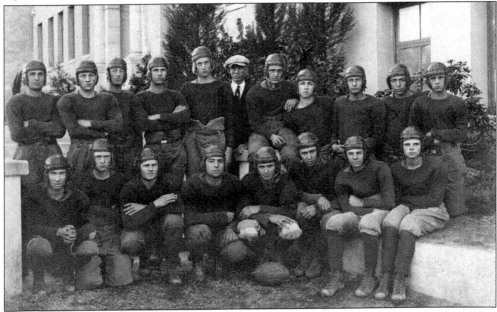

This photograph of a school football team from the 1930s shows the great attention to detail that went into the design and construction of Moorpark Memorial Union High School. The word *memorial* was a dedication to those soldiers who lost their lives in World War I. The two-story structure featured a concrete foundation, hollow tile walls, plastered exterior, tile and composition roofing, pine trim and floors, steam heating, plumbing, and wiring.

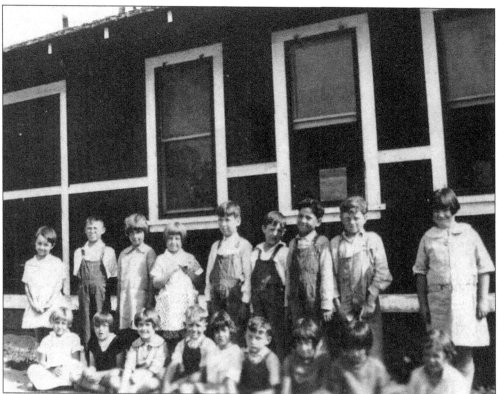

As the population of the town continued to grow, the school district quickly ran out of room to house students. In 1915, the two large rooms of the schoolhouse were divided into four rooms with a fifth room added later in the center of the building. In 1919, another ready-cut building for use as a classroom was purchased for the elementary school grounds, and students were also housed in other structures nearby. The image above shows students from the first- and second-grade classes standing in front of one of the additional school buildings. The photograph below shows the seventh- and eighth-grade students standing in front of Moorpark's newly constructed high school.

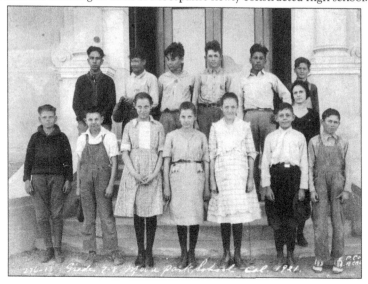

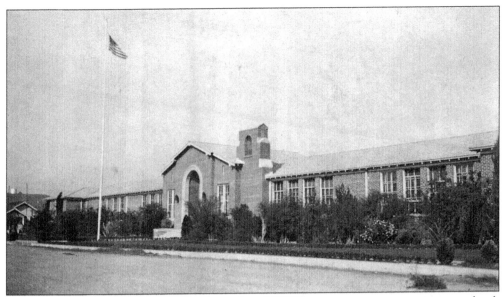

In January 1926, voters approved bonds totaling $50,000 to construct a new grammar school. After much deliberation over where to build the school, a site was chosen on the Flory ranch. Bids called for a one-story Mission-style structure of brick construction with pine trim, maple and cement flooring, gas heating, and lavatories. In this photograph, taken in 1932, the houses on Third Street can be seen in the background.

Students proudly show off their classroom projects in this photograph taken around 1935. This image is one of only a handful of surviving images that show the original all-brick building that was constructed in 1928. The school was designed with an office in the center of the building and a wing on both sides, each with three classrooms.

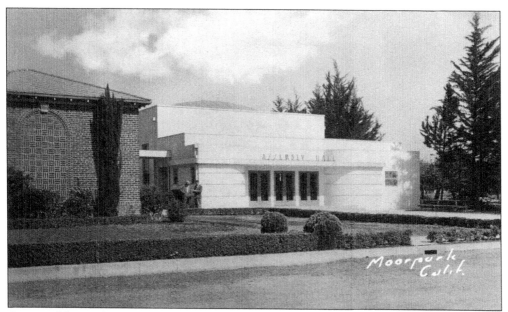

As part of the Works Progress Administration (WPA) program, the Moorpark Union Elementary School received a new auditorium in 1939. It has been home to numerous student performances and community events. The auditorium is still standing and continues to see regular use by the students and staff of Flory Academy of Sciences and Technology. (Author's collection.)

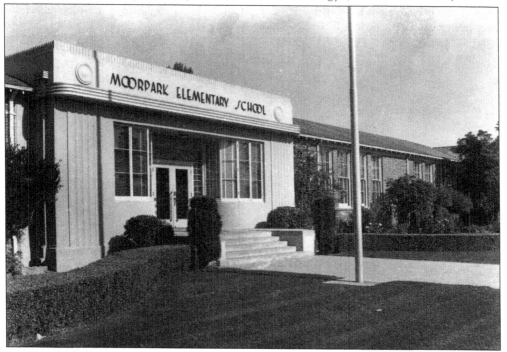

In 1939, the bell tower and office of the elementary school were removed to comply with the building specifications of the Field Act. A new Art Deco entrance was built to match the new auditorium and attached to the two existing brick classroom wings. In 1949, additional classroom wings were added and facilities were renovated.

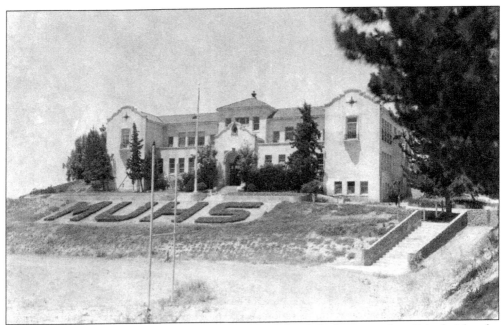

Taken in 1937, this photograph shows the high school shortly before it was demolished. After the 1933 Long Beach earthquake, the Field Act was passed by the California State Legislature. This legislation created more stringent building codes for public school structures. The large concrete steps at the bottom right led to the school's football field and remained in that location until they were removed in the late 1980s.

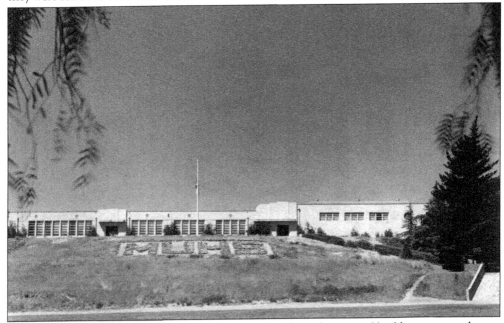

The plan for Moorpark's new high school was, at first, to keep the original building, remove the top floor, and retrofit it to meet the requirements of the Field Act. That plan, however, was rejected by the state so new plans had to be drawn up. As the year's progressed and the town grew, additional classroom wings and a library building were added to the school. (Author's collection.)

On May 6, 1939, the cornerstone was laid for the new high school. It was built in roughly the same location as the previous structure. The building project was part of the Federal Emergency Administration of Public Works, later renamed the Public Works Administration (PWA.) The PWA ran from 1935 until 1943 and spent over $6 billion in contracts paid to private firms. (Courtesy Moorpark Unified School District.)

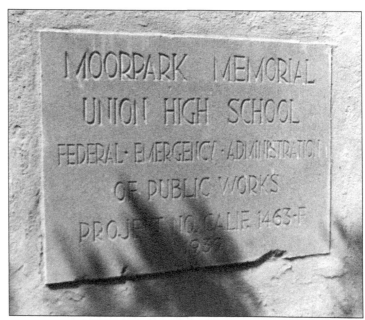

Between 1920, when the first high school was built, and 1944, when this picture was taken, there was not a substantial boom in the population of town so enrollment grew only slightly. This can be seen in the photograph of the graduating class of 1944. The class of 1944 graduated only five more students than had graduated 21 years earlier in the class of 1923. (Author's collection.)

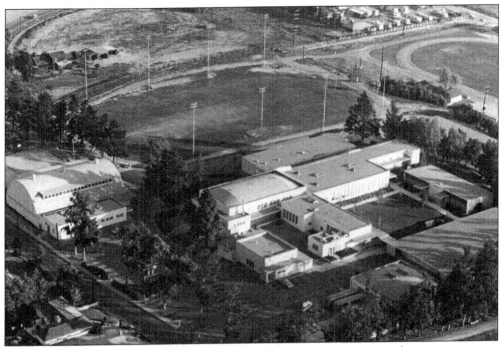

By the 1960s, Moorpark's high school had added additional classroom wings and a new gymnasium. As industry boomed and more families moved to Moorpark, the aging high school facilities were not sufficient to house the growing student body. In the mid-1980s, a location for a new campus was identified and a new school was built.

Due to limited space at Flory Street School, the voters of Moorpark overwhelming approved a building aid loan for the Moorpark Union School District in 1959. This loan of up to $905,000 was used that year to build a second elementary school on Poindexter Road. The new school was named Poindexter School after Robert Poindexter, the town's founder. In the 1980s, the name of the school was changed to Chaparral.

Seven

GROWTH

During the late 1920s, when this photograph was taken, means of transportation and roads were not the most reliable. Although Moorpark and Chatsworth are only about 29 miles apart, a trip of that distance, without the engineered roads, highways, and freeways of today, could be quite an adventure. (Author's collection.)

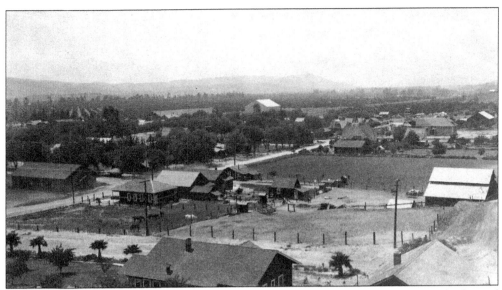

This rare view from the east end of town looking west gives a good perspective of Charles and Bard Streets. Because the schoolhouse has been remodeled but the Methodist church has not yet been enlarged, this image can be dated to between 1912 and 1919. The small house on the left with the four white-trimmed windows is the Moorpark Women's Fortnightly Club's new clubhouse. (Author's collection.)

Members of the Birkenshaw family relax outside their new home located on Moorpark Avenue across from Third Street. This house, designed by Alfred F. Priest in 1919, was built with 12 rooms, two bathrooms, a cement basement, oak floors, a solar water heater, a furnace, plumbing, and wiring. The home is still owned by the Birkenshaw family and has become a landmark in town. (Courtesy Jim and J.J. Birkenshaw.)

Electricity was first distributed in Moorpark in 1913. By the 1920s, extensive use of electricity necessitated the building of a substation that could receive high-voltage electricity and reduce it to a much lower voltage for distribution to clients. In 1922, Edison built its first substation on Los Angeles Avenue, approximately one mile from Moorpark Avenue (pictured at right). As the town grew and there was a higher demand for electric service, a second substation was built on the corner of what is now Gabbert Road and Los Angeles Avenue (pictured below). The site has been enlarged considerably over the years, but the original 1926 brick building is still standing. (Both, courtesy Huntington Library, San Marino, California.)

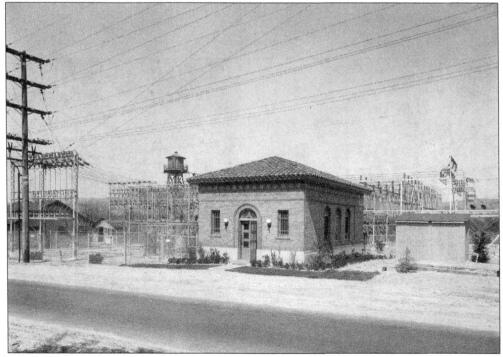

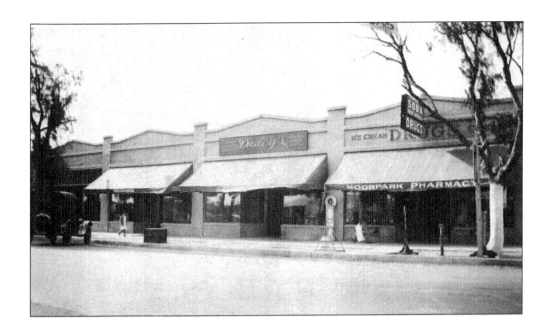

These two views are of the Whitaker's Hardware block in the 1920s. This building, originally constructed by Dr. Frank Yoakam in 1922, sits in the approximate location where the Moorpark Hotel was located from 1900 until it was destroyed by fire in 1920. In the above photograph, pioneer merchant A.B. LeRoy's store is located beneath the Daley's sign, and the Moorpark Pharmacy is to the right. In the photograph below, there is a Pickwick bus semaphore in front of the pharmacy that was used to signal passing buses of passengers waiting to be transported. And, although it is difficult to see, there is a small sign on the side of the building above the door that reads "Post Office."

This view of Moorpark Avenue is looking south towards Los Angeles Avenue and was taken between First and Second Streets sometime in the late 1910s. The Birkenshaw house, which was built just down the road in 1919, is not visible in this image so the image can be dated to before the house was constructed.

Another view of Moorpark Avenue, this time looking north, gives a great view of the majestic pine trees that once lined the road. During the late 1930s, when this photograph was taken, the land surrounding town was still primarily agricultural, which explains the fruit trees planted in the fields along the road.

The original local Catholic church was built on the corner of Everett and Magnolia Streets in 1927. The church was given the name Holy Cross (Santa Cruz). Catholic services had long been held in town in parishioners' homes and also in rented space at Mike Hoffelt's two-story building at the end of Charles Street on Moorpark Avenue.

In 1919, the Moorpark Methodist Church was enlarged by adding a second building to the north side of the structure. The building that was added was previously the M.E. Fowler Church in Somis. By joining the two structures, the size of the church was more than doubled. This view looking down Walnut Street dates from the late 1930s. (Author's collection.)

Founded in 1914, the Moorpark Chamber of Commerce served as a pseudo governing body in town and constantly looked for ways to promote business and tourism. Since apricots were such an important part of Moorpark's economy, the chamber worked with local businesses to advertise the town as the "Home of the Apricot." This detail is from an envelope of the American Commercial and Savings Bank. (Courtesy Simi Valley Historical Society.)

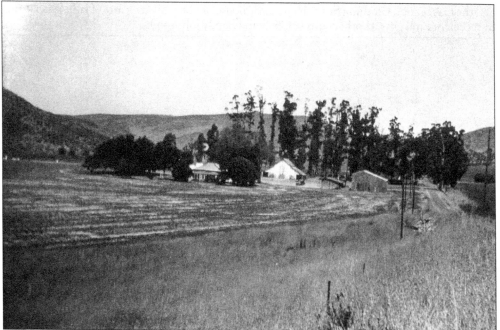

Looking to begin their own ranch, Monroe and Eldon Everett branched out and purchased the old Jones Ranch in the Tierra Rejada Valley in December 1935. Both Monroe and Eldon had grown up on ranches and had extensive experience on how to manage such an operation. (Courtesy Rick and Linnea Brecunier.)

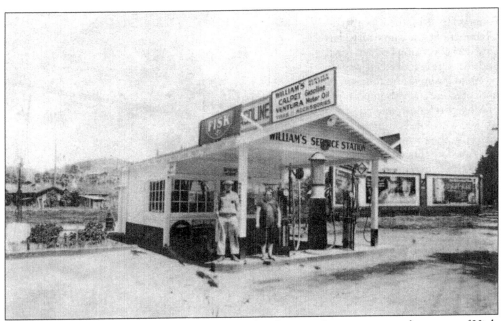

In the 1920s and 1930s, the Williams family owned and operated a gas station at the corner of High and Bard Streets. Over the years, the configuration of the building has changed. The photograph above is from the late 1920s, and the photograph below is from a few years later. In the mid- to late 1930s, the building was given a face-lift and the pitched roof and gabled front were leveled. This building has housed many different businesses, including a tire store, Four Suns Bike Shop, and the Gas Station Clothing Store. It currently houses a store called Hearts of Jade, specializing in succulents and gifts. (Both, courtesy Chris and Sandy Johnson.)

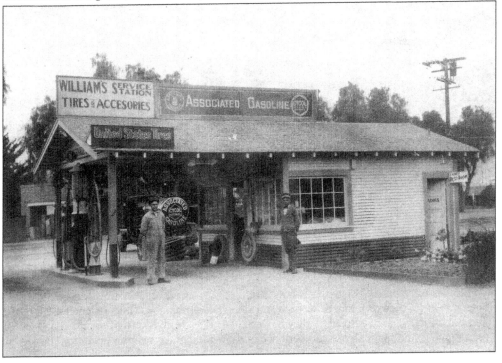

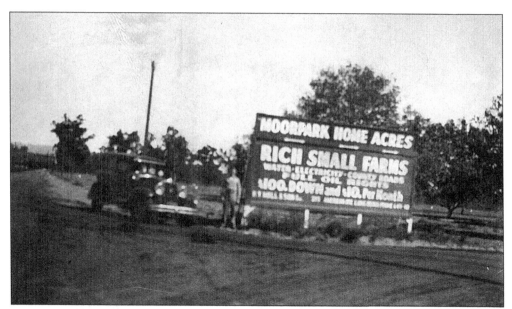

In March 1928, Sam Cohn was selling his ranch west of town in one-, two-, and five-acre lots. Since the lots were being sold in acres, the new development was given the name Home Acres. In a practice unheard-of today, patrons were give full mineral rights to the property they purchased. This photograph dates from 1932, and the view is looking east down Los Angeles Avenue with Hitch Boulevard on the right.

Home Acres attracted many families who were interested in trying their hand at farming. Although it was rumored that the soil of the area was not conducive to agriculture, residents found the opposite. This small Spanish-style house was built around 1934 and became the home of the Winters family in 1961. This photograph is dated 1962 and pictures Larry Winters. (Courtesy Larry and Nancy Winters.)

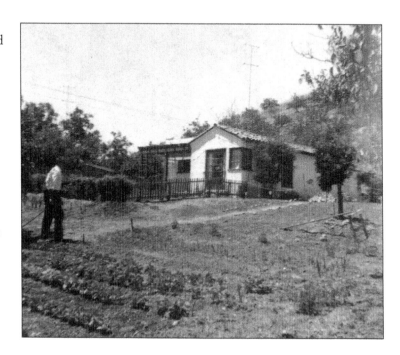

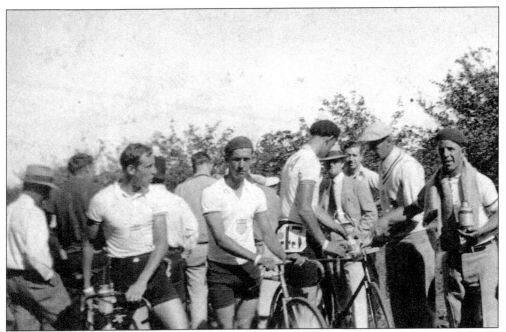

The 1932 Olympic Games brought much excitement to the area, and residents were especially honored to learn that the Olympic men's individual road race would be starting in Moorpark. The race began at the intersection of Moorpark and Los Angeles Avenues. Racers made their way to Oxnard, then down Roosevelt Highway (Pacific Coast Highway), and on to Santa Monica. Pictured here are members of the US team.

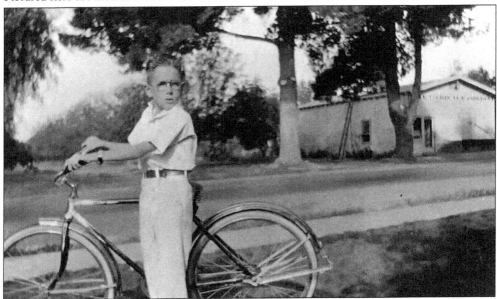

The Union Ice Company, pictured at right in this photograph, was located on the west side of Moorpark Avenue. The Moorpark Telephone Exchange building (now the Moorpark Hay Company) was eventually built next door. In the early years, and even into the 1930s and 1940s, iceboxes were still used by some residents and businesses, which necessitated delivery of large blocks of ice. Pictured next to his bicycle around 1936 is a young James Whitaker.

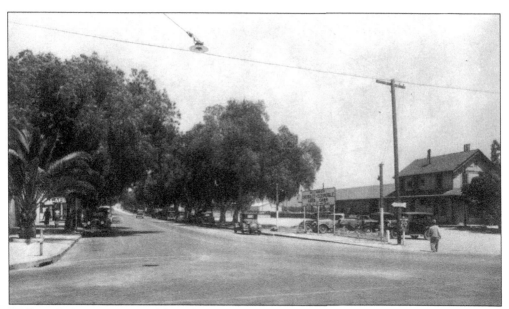

William L. Morris acquired his Chevrolet agency in Moorpark in 1933, close to when this photograph was taken. During the 1930s, the company distributed large handbills as a means to advertise its used car sales. In 1939, its offered a refinished, two-door 1933 Ford sedan for $245. Morris had his dealership on Moorpark Avenue near First Street for many years before moving to Simi Valley in 1974.

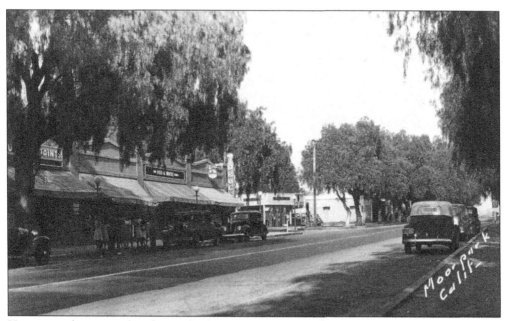

Here is another view of High Street taken in the late 1930s. By this time, Moorpark's signature pepper trees, planted between 1902 and 1903, were fully grown and provided the picturesque view that is still enjoyed today. Whitaker's Hardware is on the left, and one can just make out its Fuller Paints sign. The remodeled Williams' Service Station is also visible in the background. (Author's collection.)

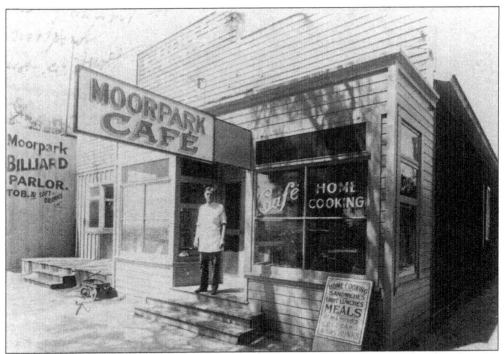

Restaurants and cafés have always been popular on High Street. Pictured here are two such cafés, both dating to around the 1930s. Above is the Moorpark Café, which was owned and operated by a Mr. Hart. Pictured below is the B&F Café, owned by two couples—a Mr. and Mrs. Fetsch and their daughter and son-in-law Mr. and Mrs. Henry Bell. Both businesses were centrally located on High Street, and the B&F Café was next door to where the theater now stands. For many years, the Moorpark Laundromat was housed in this same building.

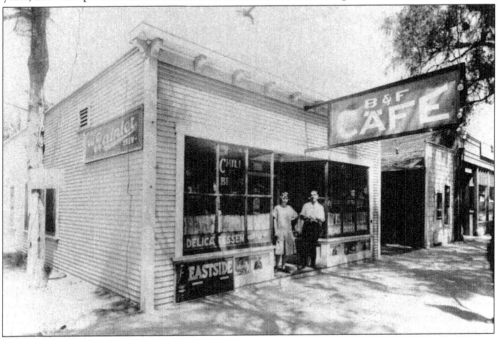

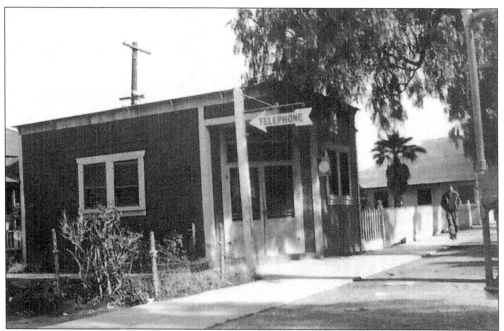

Moorpark's first library was opened in 1912 in the Moorpark Women's Fortnightly Club's clubhouse on Charles Street. Later, in June 1916, Fred McLachlin added a large room to the residence alongside his store on the corner of High and Walnut Street, and it became the Moorpark Library. This library became one of the first branch libraries in Ventura County. This photograph shows the library in 1929. (Courtesy Curran and Joy Cummings.)

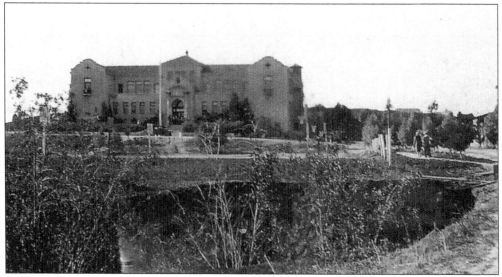

By 1929, when this picture was taken, the landscaping and athletic fields at Moorpark Memorial Union High School were complete and the school was nearly in its 10th year of operation. When the structure was finally deemed unusable because of earthquake damage, classes were held outside in tents while the new high school campus was being built. (Courtesy Curran and Joy Cummings.)

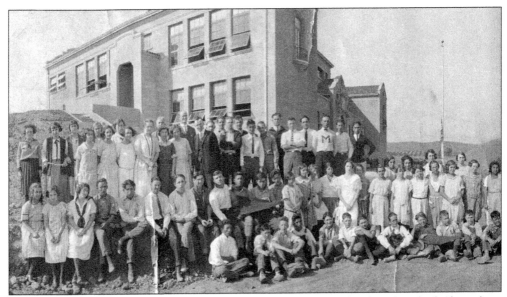

This panoramic view of the Moorpark Memorial Union High School student body dates from 1924 and provides a detailed glimpse at the south side of the structure, something that is rarely seen in photographs. The construction of the building was such that it was built into the hillside and had multilevel access.

After years of housing the Moorpark Volunteer Fire Department in I.G. Tanner's Mission Garage, the Ventura County Fire Protection District was formed in 1932. Tanner provided the organization with a building on the corner of Walnut and Everett Streets, which became Moorpark's first official fire station. The structure at right and the building in the center housed the fire department from 1942 to 1953.

The first natural gas used by Moorpark residents was butane and was supplied by the Southern Counties Gas Company from a plant installed in April 1930 on the corner of Third and Bard Streets. This plant initially served 41 residents. The plant consisted of two horizontal cylindrical tanks with an upright emergency storage tank. Eventually, 132 customers were supplied with gas from this plant. As additional storage tanks were added in town, mobile tanker trailers would deliver gas to refill them. Above is a September 1930 image of the butane trailer that would deliver gas to Moorpark residents. The same trailer is pictured below delivering gas to a storage tank on Everett Street. (Note the original Moorpark High School on the hill in the background.)

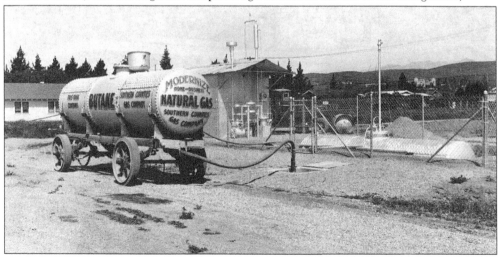

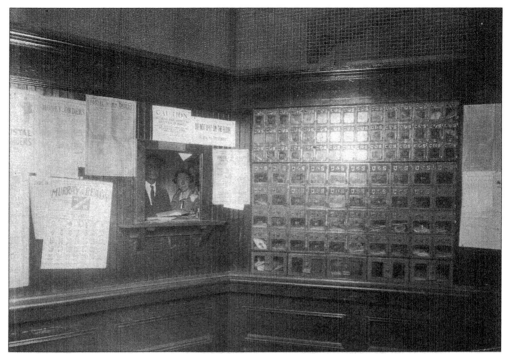

Since Moorpark's post office was established in 1900, it has almost always been on or near High Street. This c. 1930s photograph shows the interior of the post office as it was when located in one of the storefronts in the Whitaker Block. This photograph was taken while Pearl Chandler, visible in the window, was the assistant postmistress.

Sometime in the early 1920s, it was determined that a jail was needed in Moorpark to house lawbreakers who might be apprehended in the town. The small concrete building was constructed among the houses on Charles Street and was used often by Sheriff Bert Stephens, who came to Moorpark in 1944. During his time as sheriff, Stephens was responsible for policing the entire southeastern portion of the county.

Most people living in Moorpark today are not aware that the city was once a hub of turkey production in the United States. Moorpark resident and businessman Marvin Paige began his turkey operation in Moorpark around 1934. He started with a small processing plant and slowly improved his facilities until he had the most modern establishment of its kind in Southern California. Moorpark turkey rancher Edd Williams is pictured in the photograph at right inspecting his flock. Moorpark turkeys were shipped to all parts of the country to grace holiday tables, each one bearing a label that read "Moorpark, California." It was estimated in 1951 that Moorpark turkeys would serve Thanksgiving dinner to eight million people. Allen Kerr and his brother Jack, pictured below, were prominent turkey farmers in this area.

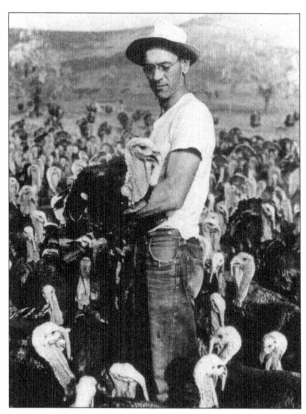

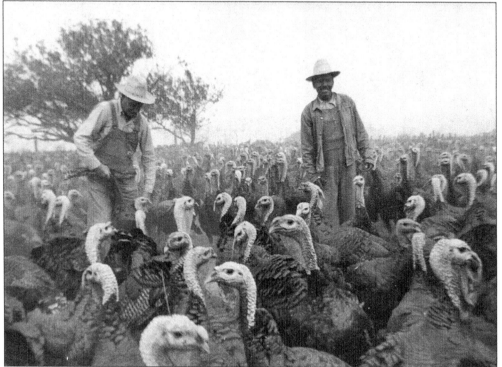

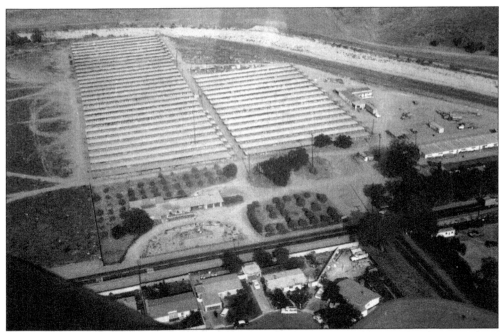

In September 1948, Dennis Johnson moved to Moorpark to relocate his poultry business from San Fernando. Moorpark had everything that Johnson was looking for—sandy soil, proximity to highways for marketing, and reasonable prices. His extensive poultry ranch was located where Los Angeles Avenue dead-ended into Spring Road, where McDonalds is located today. This photograph shows his facilities prior to the construction of the 23 Freeway.

Julius Goldman was a Jewish metallurgist who escaped persecution by the Nazis during World War II. He came to America penniless in 1949, acquired a shack in Van Nuys, and began to raise chickens and sell eggs. After saving his money, he purchased a small feed mill in Moorpark. By February 1961, he expanded his business and founded Egg City, which became one of the largest egg-producing farms in the world.

Eight

HIGH STREET

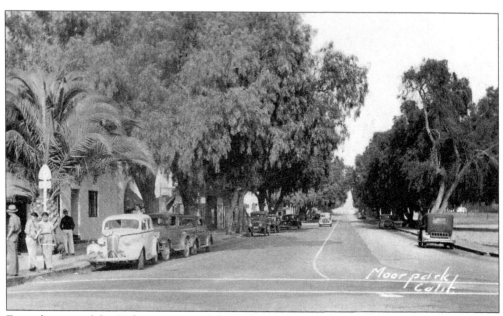

From the turn of the 20th century until the early 1980s, High Street was considered Moorpark's main business thoroughfare. It provided access to the depot, the mercantile, the bank, restaurants, the theater, the hotel, the library, the school, churches, and so much more. This last chapter is a collection of images of High Street throughout the years.

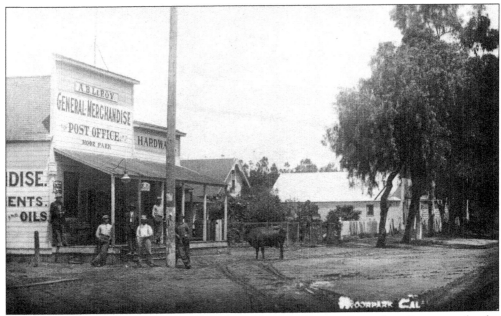

This photograph, taken around 1915, shows A.B. LeRoy's general merchandise store after he dissolved his partnership with Art Gillies. By this time, LeRoy had been in Moorpark for nearly 10 years so he was a permanent fixture on High Street. Stores like the one pictured here were gathering places where townspeople could meet and catch up on the latest news or gossip.

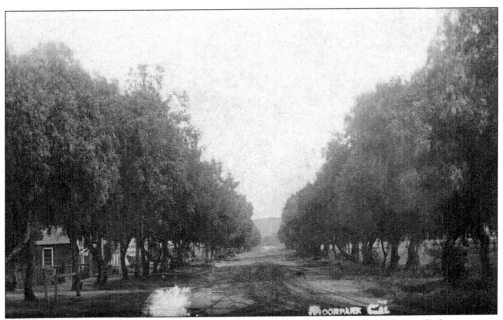

This photograph was taken on the same day and by the same photographer who took the previous image. When reading historical accounts of the early years of Moorpark, it is very apparent that the weather controlled both the commerce and activities of the town. Before the streets were paved, even a moderate rainfall could create lots of mud and even more havoc.

Lots that were vacant on High Street in 1910 were beginning to fill up when this photograph was taken around 1915. For a point of reference, one can just make out the lettering on A.B. LeRoy's store in the distance. It is unknown who lived in the attractive dual-chimney home on the left, but it is a prominent structure in even the earliest views of town.

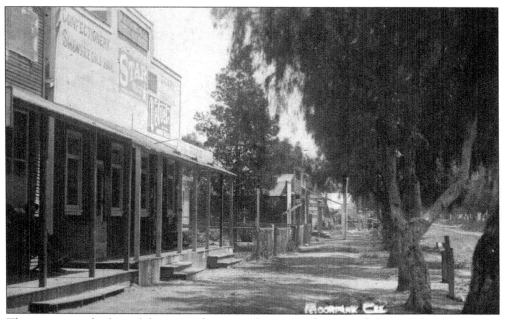

This picture is the last of the series that was taken around 1915 and shows Robert E. Young's merchandise store along with James Barrett's billiards parlor. As many townspeople still relied on horse and buggy for travel, businesses still had hitching posts out front that patrons could use to tether their horses.

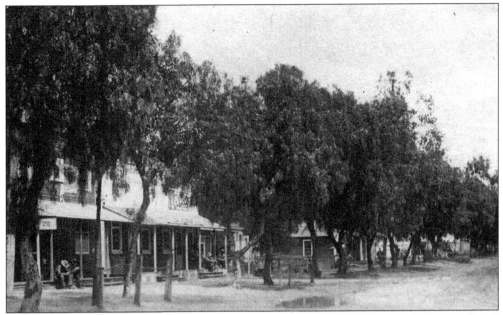

Here is another view looking east down the north side of High Street. It was taken around 1916 and provides another view of Robert Young's store. According to the advertising on the building, Young's store truly does appear to be a one-stop shop, advertising groceries, ice cream, candy, ice-cold soda, cigars, and smoking tobacco.

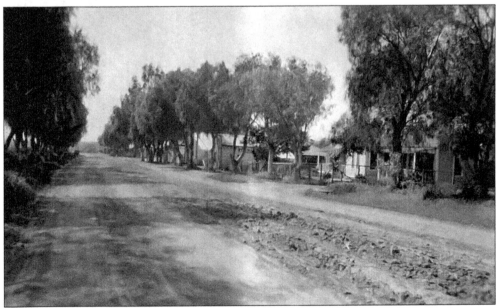

This photograph was taken around 1914 when High Street was still a dirt road. It provides a very early view looking west to where High Street dead-ends into Moorpark Avenue. The Moorpark Hotel, which was located between Bard and Walnut Streets, can be seen on the right.

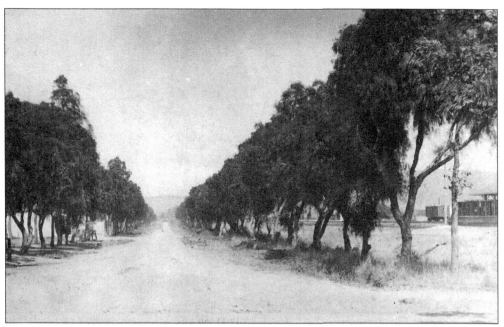

The covered freight platform of the Moorpark depot, along with freight cars, can be seen on the extreme right of this image. It was taken sometime in the 1910s and the view looks east down High Street. The *Oxnard Courier*, on two occasions—once in 1902 and once in 1903—mentioned shipments of shade trees being sent to town by Robert W. Poindexter to help give the townsite a better appearance.

This view of the Moorpark Hotel shows a sign that advertises that the establishment has a public telephone, dating this photograph to sometime after the Moorpark Telephone Exchange switchboard was installed on Charles Street in 1908. The block building on the left-hand side of the image is Frank Cornett's meat market. (Author's collection.)

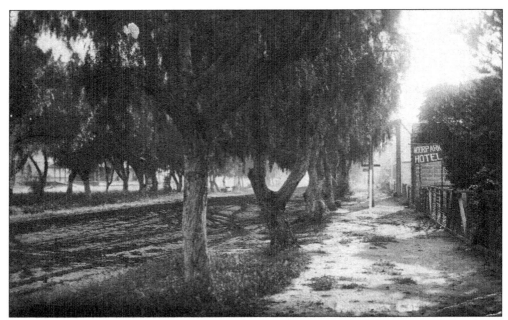

This is a more detailed view of the north side of High Street and of the Moorpark Hotel and Frank Cornett's meat market. As mentioned earlier, newspaper reports of the day recount the vital role the weather played in the daily life of the citizens. This was especially true with inclement weather, which included both rain and the east winds that are still quite prevalent today.

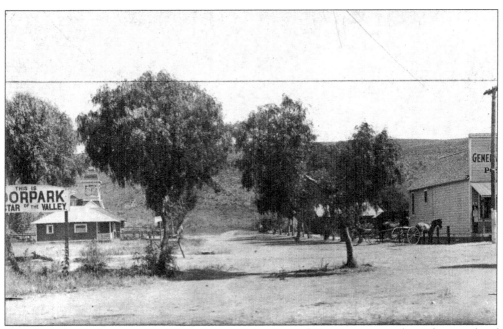

An article in the January 28, 1910, edition of the *Oxnard Courier* reports that "the people of Moorpark are preparing a sign advertising their little town and will place it near the railroad." By February 4, the sign was complete and erected at the corner of High Street and Walnut Avenue. It read, "This is Moorpark, Star of the Valley."

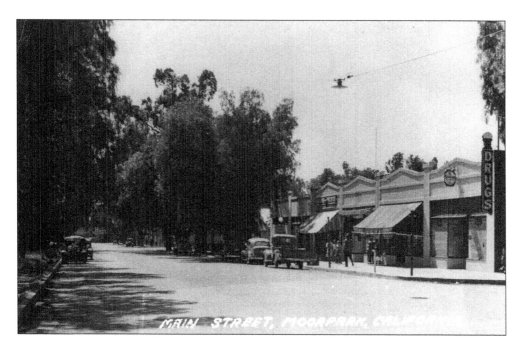

These two images, taken by the same photographer on the same day, show views looking west on High Street in the 1930s. It was very common for traveling photographers to visit a town and record images of the main streets, structures, and attractions. They would then make prints of the images on postcard stock and take them around to local business owners, who would purchase them to sell to both townsfolk and tourists. The above photograph shows the Whitaker Block from Bard Street to Walnut Street. The image below shows Walnut Street to Moorpark Avenue and includes, on the right-hand side, Fred McLachlin's rebuilt general merchandise store. (Both, author's collection.)

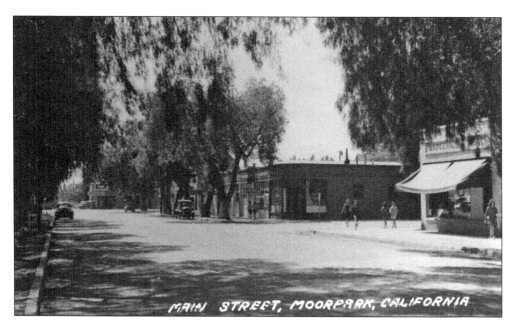

Visit us at
arcadiapublishing.com

..